PICTOGRAPHIC
INDEX 1

edited by Hans Lijklema

written and compiled by
Karolina & Hans Lijklema

THE PEPIN PRESS

For Weronika

English text editing by Rosalind Horton
Translations by Sebastian Viebahn (German),
The Word Counter (French), and LocTeam (Spanish)
Editorial and production coordination by
Kevin Haworth

Cover and book design by Hans Lijklema
www.lijklema.waw.pl

Copyright cover illustration © 2009 John Solimine/
Spike Press (see pages 268-279). www.spikepress.com
Copyright endpaper pattern © 2009 Ray Fenwick
(see pages 82-93). www.rayfenwick.ca
This book was set in Museo and Museo Sans.
www.exljbris.com

Pictographic Index 1
ISBN 978 90 5768 134 9
The Pepin Press | Agile Rabbit Editions
Amsterdam & Singapore

The Pepin Press BV
P.O. Box 10349
1001 EH Amsterdam
The Netherlands

Tel +31 20 4202021
Fax +31 20 4201152
mail@pepinpress.com
www.pepinpress.com

10 9 8 7 6 5 4 3 2 1
2016 15 14 13 12 11 10

Manufactured in Singapore

Contents

Introduction (EN) 5

Einführung (DE) 7

Introduction (FR) 9

Introducción (ES) 11

Interviews (EN)
Ray Fenwick 14
Jochen Gerner 20
Max Kisman 26
Andy Smith 32
Spike Press 38
Henning Wagenbreth 44

Artist Profiles
Atelier René Knip 52
Jordan Crane 64
Piotr Fąfrowicz 74
Ray Fenwick 82
Jochen Gerner 94
Linzie Hunter 106
Jan Kallwejt 118
Max Kisman 130
Stuart Kolakovic 142
Kuanth 154
Sebastian Kubica 164
Lab Partners 174
Seb Lester 184
Maki 192
Misprinted Type 204
Patryk Mogilnicki 212
Janine Rewell 220
Nicolas Robel 232
Shamrock 244
Andy Smith 256
Spike Press 268
Martin tom Dieck 280
Irina Troitskaya 288
Jack Usine 296
Henning Wagenbreth 308

Introduction

In the past, most graphic designers and illustrators were very versatile and it was often impossible to draw a strict line between these two professions. For example, the illustration and design of book covers were often done by one and the same person. A lot of the lettering was of the same quality as metal type, but because it had been created by hand, the style of the artist was more recognisable. Most of the time such work was undertaken because of the lack of technical possibilities, rather than by choice.

In the sixties, thanks to the invention of photosetting and the influence of Swiss design, most designers started to abandon illustration and lettering in favour of scissors, glue and grids. Illustration was also steadily being replaced by photography. Most graphic designers stopped producing illustrations themselves and their work became more and more like an assembly job. It was at this point that graphic design and illustration went their separate ways. Of course, there have always been individuals who have carried on combining those two disciplines.

In recent decades, computers have put the tools that previously were only available to large studios into the hands of individual artists. Illustration and graphic design have started to melt together more and more.

A new generation of artists is less concerned with the divide that existed in the minds of their predecessors. Lettering (also in the form of custom typefaces) is making a real comeback as a means of personal expression, which could be perceived as a reaction against a lot of the sterile design work out there. It seems as if we have come full circle.

When starting to compile this book, we had to consider which artists and what kind of work to include. There are so many brilliant projects and inspiring solutions, that it was very difficult to decide who would make the cut and who wouldn't. We selected artists whom we appreciate for different aspects of their work. Some were already known to us, but we also discovered other talented people who had been off our radar before working on this book.

First of all we wanted this to be a visually orientated book and that's probably why working on it often reminded us of planning a group exhibition (in this case involving 25 artists). From time to time one of the participants

would ask why we didn't include a particular work they had send us. Often the reason was that two good illustrations or designs won't necessarily look good next to each other. It was important for us to make a selection that shows every artist's output as a coherent body of work. Our choice is, of course, a subjective one. By showing a specific part of an artist's output we were trying to catch the essence of his or her style and show their pure talent. In some cases this resulted in presenting just a small part of their overall capabilities, for example because we wanted only to include work that was not too heavily constrained by any client requirements. This was also why we decided to include a fair amount of personal work in this book. These projects give artists a chance to experiment within their own discipline, cross over into others and really be themselves.

In a way it might seem like a contradiction to include personal work in a book about applied art, but we feel that it is justified for another reason. Although these works didn't originate from any assignment given by a client, they are often produced with the intention of putting them up for sale later on. Sites like Etsy and Threadless give artists a chance to sell books, limited edition prints, badges, T-shirts and other products based on their own work to a worldwide audience. In other cases personal projects find themselves a publisher or producer, because somebody becomes aware of them through an artist's blog or Flickr stream. Thanks to all those possibilities these personal projects become a form of applied art in their own right.

In this book you will find illustrations, graphic design and everything in between. If you are working in the same field, the works presented here might inspire you to take a more personal approach to your own work. If you have already found your own path, the work of other talented professionals will hopefully confirm that you are on the right track.

We hope that for everybody else this book will serve as an introduction to the artists included and provide a starting point to find out more about them and their work.

We would like to thank John Solimine of Spike Press for agreeing to have his illustration reproduced on the cover of this book and Ray Fenwick for his pattern that we used for the endpapers. Of course, most of all we thank our daughter Weronika for putting up with the laptops on the dinner table.

Karolina & Hans Lijklema

Einführung

In der Vergangenheit arbeiteten die meisten Grafikdesigner und Illustratoren sehr vielseitig und oft war es unmöglich, eine klare Trennlinie zwischen den beiden Berufsbildern zu ziehen. Vielfach stammten die Illustration und die Gestaltung von Bucheinbänden von ein und derselben Person. Dabei erreichten die Schriften typografisch oft die Qualität von Metalldrucktypen, doch trat der Stil des Künstlers erkennbarer zu Tage, weil die Schrift von Hand geschaffen war. Meist arbeitete man aber nicht aus freier Entscheidung so, sondern wegen der fehlenden technischen Möglichkeiten.

Nach der Erfindung des Fotosatzes und unter dem Einfluss des Schweizer Designs zeichneten die meisten Designer ab den 1960er-Jahren ihre Illustrationen und Schrifttypen nicht mehr selbst, sondern griffen zu Schere, Kleber und Raster. Langsam, aber sicher verdrängten Fotos die Illustrationen. Die meisten Grafikdesigner stellten selbst keine Illustrationen mehr her und ihr Job wurde zunehmend zur Fließbandarbeit. An diesem Punkt trennten sich die Wege von Grafikdesign und Illustration. Natürlich gab es auch weiter einzelne Künstler, die auf beiden Gebieten arbeiteten.

In den letzten Jahrzehnten haben die Computer dem einzelnen Künstler Werkzeuge an die Hand gegeben, die vorher nur größeren Ateliers zu Verfügung standen. Illustration und Grafikdesign beginnen immer stärker zusammenzuwachsen. Die in den Köpfen der alten Garde präsente Trennung hat bei Künstlern der neuen Generation ziemlich wenig Bedeutung. Das Schriftdesign erlebt (teils in Form selbst entworfener Fonts) ein echtes Comeback als Mittel persönlichen Ausdrucks, das man auch als Reaktion auf die sterilen 08/15-Massendesignproduktionen sehen kann. Offenbar schließt sich der Kreis also wieder.

Als wir begannen, dieses Buch zusammenzustellen, mussten wir entscheiden, welche Künstler und welche Sorte von Arbeiten wir aufnehmen wollten. Es gibt so viele brillante Projekte und faszinierende Ideen, dass es sehr schwierig war zu entscheiden, wer denn nun das Rennen machen sollte - bzw. wer nicht. Wir haben Künstler ausgewählt, die uns wegen ganz unterschiedlicher Aspekte ihrer Werke gefallen. Einige kannten wir schon, aber wir haben auch andere talentierte Zeichner entdeckt, von denen wir nie gehört hatten, bevor

wir an diesem Buch zu arbeiten begannen. Zunächst einmal sollte es ein visuell ausgerichtetes Buch werden; wohl auch deshalb kam uns die Arbeit daran oft fast so vor, als würden wir eine Gruppenausstellung mit 25 Teilnehmern organisieren. Hin und wieder fragten uns einzelne Künstler, warum wir nicht dieses oder jenes bestimmte Werk mit aufnahmen, das sie uns zugeschickt hatten. Der Grund dafür war oft, dass zwei gute Illustrationen oder Designs nicht immer gut wirken, wenn man sie nebeneinander präsentiert.

Für uns war es wichtig, eine Auswahl zu treffen, die das Gesamtwerk des jeweiligen Künstlers als zusammenhängendes Oeuvre darstellt. Natürlich ist unsere Auswahl subjektiv. Indem wir einen bestimmten Teil des Oeuvres eines Künstlers zeigen, versuchen wir, das Wesentliche seines Stils und seiner Fähigkeiten aufzuzeigen. Das läuft manchmal darauf hinaus, nur einen kleinen Teilausschnitt all seiner Fähigkeiten vorzustellen, beispielsweise weil wir nur Arbeiten aufnehmen wollten, die nicht zu stark von Kundenvorgaben geprägt sind.

Aus diesem Grund beschlossen wir auch, eine gute Portion persönlicher, nicht als Auftragsarbeiten entstandener Arbeiten aufzunehmen. Bei solchen Projekten können Künstler in ihrer ureigensten Domäne experimentieren, in andere überwechseln, und ihre Persönlichkeit voll zum Ausdruck bringen.

Persönliche Arbeiten in ein Buch über angewandte Kunst aufzunehmen mag paradox erscheinen, hat jedoch insofern seine Logik, als solche Werke zwar nicht im Kundenauftrag entstehen, aber oft mit der Absicht geschaffen werden, sie später zu vermarkten. Websites wie Etsy und Threadless ermöglichen Künstlern, ihre Bücher, limitierten Prints, Sticker, T-Shirts und andere Arbeiten an ein weltweites Publikum zu verkaufen. In anderen Fällen findet sich ein Herausgeber oder Produzent für persönliche Projekte, weil jemand über den Blog oder Flickr-Stream des Künstlers auf sie aufmerksam wird. Wegen all dieser Optionen und Möglichkeiten kann man auch die persönlichen Projekte durchaus als angewandte Kunst bezeichnen.

In diesem Buch findet man Illustrationen, Grafikdesign und alles, was dazwischen liegt. Wer selbst auf dem Gebiet arbeitet, wird hier vielleicht inspiriert und findet zu einer persönlicheren Einstellung zur eigenen Arbeit. Wer schon seinen individuellen Ausdruck gefunden hat, sieht sich angesichts der Arbeit von talentierten Profis vielleicht in seinem Weg bestätigt. Allen anderen mag dieses Buch vielleicht helfen, einen ersten Eindruck von den gezeigten Künstlern zu erhalten und sie und ihre Arbeiten womöglich näher kennen zu lernen.

Unser Dank gilt John Solimine von Spike Press, der uns erlaubt hat, seine Illustration auf dem Buchdeckel zu reproduzieren, und Ray Fenwick, der uns ein Muster für die Vorsatzblätter zur Verfügung gestellt hat. Am allermeisten danken wir natürlich unserer Tochter Weronika, die mit den Laptops auf dem Esstisch leben musste.

Karolina & Hans Lijklema

Introduction

Autrefois, la distinction entre designer graphique et illustrateur, deux professions alors hautement polyvalentes, était quasi inexistante. À titre d'exemple, l'illustration et la conception d'une couverture de livre étaient généralement réalisées par une seule et même personne. Qualitativement similaires aux caractères en métal, la plupart des lettres utilisées laissaient toutefois transparaître le style de l'artiste, du fait de leur facture artisanale. En règle générale, ce travail résultait plus d'un manque de possibilités techniques que d'un choix esthétique.

Dans les années soixante, grâce à l'avènement de la photocomposition et à l'influence du design helvétique, la plupart des designers commencent à se détourner de l'illustration et du lettrage au profit des ciseaux, de la colle et des grilles. L'illustration, quant à elle, perd progressivement du terrain face à la photographie. Une grande majorité de designers graphiques renoncent à produire eux-mêmes leurs illustrations et leurs activités s'apparentent de plus en plus à un travail d'assemblage. La distinction entre design graphique et illustration était née. Bien sûr, il y aura toujours des artistes qui continueront à combiner ces deux disciplines.

Au cours des dernières décennies, l'introduction des ordinateurs a permis à des artistes indépendants d'accéder à des outils qui étaient jusqu'alors réservés aux grands studios. La distinction entre illustration et design graphique commence de plus en plus à s'effacer. Il émerge une nouvelle génération d'artistes, moins préoccupée par la distinction existant dans l'esprit de ses prédécesseurs. Moyen d'expression personnelle et réaction probable à la stérilité artistique de nombreux travaux, le lettrage (qui inclut également la customisation des caractères) fait un véritable come-back. La boucle est bouclée.

Lorsque nous nous sommes lancés dans la compilation de cet ouvrage, nous nous sommes trouvés confrontés à un choix très difficile, à savoir, quels artistes et quelles œuvres sélectionner pour ce projet. Il existe une telle multitude de projets brillants et de solutions enthousiasmantes ! Nous avons sélectionné des artistes que nous apprécions pour les différents aspects de leur travail. Si nous connaissions déjà un certain nombre d'entre eux, nous avons également découvert de nouveaux talents qui n'étaient pas dans notre ligne de mire avant la réalisation de ce livre.

Nous voulions avant tout que ce livre soit une expérience visuelle et c'est probablement pour cette raison que nous avions souvent l'impression de préparer une exposition collective (rassemblant, dans ce cas précis, quelques 25 artistes). Certains participants nous ont parfois demandé pourquoi nous n'avions pas inclus tel ou tel travail. Bien souvent, la raison était purement esthétique : deux excellentes illustrations ou concepts ne sont pas nécessairement mis en valeur l'un à côté de l'autre.

Pour nous, l'important était de sélectionner des travaux permettant de révéler la cohérence de l'œuvre de chaque artiste. Ces choix sont bien sûr parfaitement subjectifs. En choisissant de ne dévoiler qu'une partie spécifique de leurs œuvres, nous avons essayé de capturer l'essence de leur style et de révéler leur talent à l'état pur. Cette approche implique que dans certains cas, seule une infime partie des capacités totales de l'artiste est représentée (excluant par exemple les travaux tenant trop compte des contraintes et des exigences de leurs commanditaires). C'est également pour cette raison que nous avons choisi d'inclure dans ce livre un échantillon représentatif de leurs travaux personnels. Ces projets offrent aux artistes l'opportunité d'expérimenter au sein de leur propre discipline et d'empiéter sur d'autres, révélant ainsi leur véritable personnalité.

Cette volonté d'inclure des travaux personnels dans un livre sur l'art appliqué peut paraître contradictoire. Mais à nos yeux, il n'en est rien ; car bien que ces travaux n'aient pas été commandités, ils sont généralement produits pour être vendus ultérieurement. Les plates-formes de vente en ligne telles que Etsy et Threadless donnent aux artistes l'opportunité d'offrir leurs livres, leurs sérigraphies en éditions limitées, leurs badges, leurs tee-shirts et toute une gamme de produits basés sur leurs propres travaux à un public international. Qui plus est, ces travaux peuvent arriver dans les mains d'un éditeur ou d'un fabricant après avoir attiré l'attention d'un individu sur le blog ou la galerie Flickr de l'artiste. Grâce à ces myriades de possibilités, les travaux personnels des artistes deviennent une forme légitime d'art appliqué.

Vous trouverez dans ce livre des illustrations, des créations graphiques et toutes formes d'art intermédiaires. Si vous travaillez dans la même branche, il se peut que les travaux présentés dans cet ouvrage vous inspirent une approche plus personnelle de votre travail. Si vous avez déjà trouvé votre voie, les travaux d'autres professionnels talentueux confirmeront, avec un peu de chance, que vous êtes sur la bonne piste.

Quant aux autres « spectateurs », nous espérons que cet ouvrage vous servira d'introduction aux artistes mentionnés, vous invitant à mieux connaître leur démarche et leur travail.

Nous aimerions remercier John Solimine de Spike Press pour avoir accepté de prêter l'une de ses illustrations à la couverture de ce livre et Ray Fenwick pour ses modèles personnalisés de feuilles de garde. Et enfin et surtout, notre fille, Weronika, pour avoir supporté nos ordinateurs portables à la table familiale.

Karolina et Hans Lijklema

Introducción

En el pasado, la mayoría de los diseñadores gráficos e ilustradores eran personas muy versátiles y a menudo resultaba imposible trazar una línea clara entre ambas profesiones. Por ejemplo, la ilustración y el diseño de la cubierta de un libro solía ejecutarlos la misma persona. Gran parte de los rótulos usaban letras muy parecidas a las de los tipos metálicos, si bien, al estar compuestas a mano, el estilo del artista resultaba más reconocible. En la mayoría de los casos este trabajo se realizaba así por falta de posibilidades técnicas y no por voluntad.

En la década de 1960, gracias a la invención de la fotocomposición y a la influencia del diseño suizo, los diseñadores comenzaron a abandonar la ilustración y el rotulado a favor de las tijeras, la cola de pegar y las retículas. La ilustración se vio paulatinamente remplazada por la fotografía. La mayoría de los diseñadores gráficos dejaron de producir ilustraciones con sus propias manos y su obra devino cada vez más una labor de ensamblaje. Llegados a este punto, el diseño gráfico y la ilustración tomaron caminos distintos, si bien siempre ha habido individuos que han continuado combinando ambas disciplinas.

En las últimas décadas, los ordenadores han puesto en manos de todos los artistas herramientas a las que previamente solo tenían acceso los grandes estudios. La ilustración y el diseño gráfico han empezado a fusionarse, y cada vez se integran más. La nueva generación de artistas está menos preocupada por la división que existía en las mentes de sus predecesores. El rotulado (también en la forma de tipografías personalizadas) vive un renacimiento en tanto que medio de expresión personal, cosa que podría percibirse como una reacción frente a la infinidad de trabajos de diseño estériles que inundan el mercado. Todo apunta a que hemos cerrado el círculo.

Antes de empezar a trabajar en este libro tuvimos que sopesar a qué artistas y qué tipo de trabajos nos interesaba incluir. Son tantos los proyectos brillantes y las soluciones inspiradoras que resulta sumamente difícil aventurar quién acabará por romper moldes y quién no. Seleccionamos a artistas a quienes valoramos por distintos aspectos de su trabajo. A algunos ya los conocíamos, pero también descubrimos a otros profesionales de talento que hasta ahora habían quedado fuera del alcance de nuestro radar.

Ante todo, nuestra voluntad era que este fuera un libro que primara la imagen; de ahí, probablemente, que trabajar en él nos recordara a planificar una exposición colectiva (en este caso compuesta por 25 artistas). De vez en cuando, uno de los participantes nos preguntaba por qué no habíamos incluido una de las obras que nos había enviado. A menudo la razón era que dos buenas ilustraciones o dos buenos diseños no funcionan necesariamente bien cuando se yuxtaponen.

Para nosotros era importante componer una recopilación que mostrara la producción de cada artista como una obra global coherente. Como no podría ser de otro modo, se trata de una recopilación subjetiva. Al exhibir una parte específica de la producción de un artista intentamos captar la esencia de su estilo y mostrar su talento en estado puro. En algunos casos, esta voluntad nos ha llevado a presentar tan solo un atisbo de sus dotes, por ejemplo porque solo nos interesaba publicar trabajos que no hubieran estado sometidos a fuertes restricciones impuestas por un cliente. Este fue también el motivo por el que decidimos incluir una cantidad considerable de obra personal en este libro. Nos interesaban los proyectos que ofrecen a los artistas la posibilidad de experimentar dentro de los límites de su propia disciplina, desbordarlos y dar rienda suelta a su creatividad.

En cierto sentido puede parecer contradictorio enseñar obra personal en un libro acerca de las artes aplicadas, pero consideramos que está justificado, ya que, si bien estos trabajos no son fruto del encargo de un cliente, a menudo se producen con la intención de comercializarlos posteriormente. Sitios web como Etsy y Threadless ofrecen a los artistas una oportunidad de vender a público de todo el mundo libros, impresiones de edición limitada, chapas, camisetas y otros artículos basados en su propia obra. En otros casos, los proyectos personales encuentran un editor o productor por sí solos, porque alguien tiene noticia de ellos a través del blog del artista o un enlace de Flickr. Gracias a todas estas posibilidades, estos proyectos personales se convierten en una forma de arte aplicado por derecho propio.

En este libro encontrará ilustraciones, proyectos de diseño gráfico y todo el espectro entre ambas disciplinas. Si trabaja en este mismo campo, las obras expuestas tal vez le inspiren a replantearse su propio trabajo para darle un tinte más personal. Si ya ha encontrado su propio camino, es de desear que la contemplación del trabajo de profesionales de referencia le confirme que avanza por la senda correcta. En términos generales, esperamos que esta recopilación sirva para dar a conocer a los artistas incluidos al público general e incite a buscar más información sobre su trayectoria y sobre su obra.

Nos gustaría expresar nuestro agradecimiento a John Solimine, de Spike Press, por acceder a que su ilustración aparezca en la cubierta de este volumen y a Ray Fenwick por la trama que hemos utilizado en las guardas. Por supuesto, vaya nuestro más sincero agradecimiento a nuestra hija, Weronika, por tolerar la omnipresencia de los ordenadores portátiles en la mesa a la hora de cenar.

Karolina y Hans Lijklema

Interviews

Interview

Ray Fenwick

You are a former improv comedian and theatre school dropout. It seems quite a change to what you are doing now...

RF: First off, I should be clear here and say that I did that stuff quite a while ago now, over ten years ago, so the change wasn't as abrupt as you might think. There was a long transition time in there. That said, I've taken a lot with me from those experiences. Improv comedy is about being in the moment and relying on intuition, and I have the most fun when doing exactly that, even when drawing. Improv allows you to surprise yourself, which is always something I'm looking for ... rarely achieving, but always looking for.

There is a lot of subtle humour in your work, either in the text or in the drawings themselves. You seem to have a lot of fun creating your work. Is that true? Is this also something that you took with you from your time as an improv comedian?

RF: Yes, humour has always been a part of my life. I wouldn't say I'm the funniest person I know, but I would say that over the years I've hung around with some pretty funny people, and I think that has rubbed off on me. I do have fun when I'm working on things, but to be honest it's a mix of fun and anxiety. I laugh to myself sometimes while drawing something or working on an idea, but there are also times when something isn't working and I feel as though the world is one big torture chamber. I think that kind of thing comes through in everything I do, even in the lines I draw. I would say I have a line that is both ridiculous and anxious at the same time.

I like there to be a bit of contrast in there – a bit of failure and diffidence – because that's honest. Or, at least, for me it is.

Can you tell me something more about the formal art education you received?

RF: I have a university education, but it was in graphic design, albeit at an art school where I was also taking a lot of non-design courses. There was a time when I actually wanted to do type design, and I imagined that was what I'd do with my life, but it slowly dawned on me that the drawing and writing was more personally appealing. Typography was my main interest in design school, though – that and filling my notebooks with weird stuff. Further back than that, I've always been

interested in drawing and writing. Not so much drawing from life, but drawing nonetheless. In high school, I used to try to entertain or shock my friends with outrageous and obscene drawings. That mode of communication still appeals to me. Maybe that means I'm emotionally stunted. I still do lots of things like that, where the drawing and lettering is an attempt at intimacy or conspiratorial messing around. A bit like note passing in school lessons.

What part of your graphic design education is most useful for your work today?

RF: That's a hard question for me to answer, because these days I find myself wanting to get rid of some of the designer in me. When working on art, I find the designer in me won't let something be open-ended, and that's frustrating. Designers often have this intense desire to communicate an idea directly, with no room for interpretation, but in art that's counter-productive. That's bad art. That said, one of the great things about my design education is that my professors had a very loose definition of what a designer is and what kind of work they do. It was so loose that sometimes they treated designers as though they

were conceptual artists. I think this gave me permission to work on what interested me, regardless of whether it was 'design' or not.

What are your inspirations for your lettering?

RF: It really depends on the project, but it's all based on some archetype. I went through countless sketchbooks learning different letters and typefaces, more out of curiosity than anything else. There was a time when I just wanted to catalogue all these lettering styles, but rather than learn them properly I would draw a few letters and then finish the rest without referring back to the original. I think that approach works for me because what I'm after is an interpretation of something, not a copy. The very first thing I did, though, before all that, was to learn the most basic forms of letters. You have to have that as a base or your interpretations end up looking amateurish.

Since you had your passion for type design and now do a lot of lettering, have you ever considered turning some of your lettering into fonts or creating some new typefaces from scratch?

RF: No, absolutely not. I think typefaces kill

the spirit of hand lettering. I'm totally against that. I don't think my letters or writing are original, but they are personal, so to turn them into endlessly reusable objects just seems to lack integrity. I would just feel weird about seeing that. It'd be like someone dancing around wearing your skin. Creepy.

As we are on the subject of lettering... Letters play an important role in your work. Sometimes they are the main focus, at other times they take a back seat, but they are always present. Where did your passion for letters come from?

RF: I think text, letters and writing have always been a more natural way for me to communicate. I love to draw, but I love writing just as much, so I feel like I'm on this path of trying to marry the two, to draw and write at the same time. When there isn't a balance, I feel less happy with the work. For instance, if someone asks for something that is pure lettering, and they want me to just replicate something I've already done, it doesn't feel right. I'm not the greatest designer, calligrapher, letterer, writer or even artist, but my hope is that when those things are combined there is a sensibility that is more than the sum of its parts. So to take a part out kind of exposes my weaknesses and ruins everything. It's still not sorted out, at all. I just can't bring myself to pick one thing – so maybe in ten years I'll reach the point where I feel it's coming together properly.

What about patterns? Your idea for narrative patterns is something truly original...

RF: I haven't done many patterns recently, but I know there is a lot to be done there, especially in the sphere of art. There are a lot of things that qualify as patterns – all it takes is repeating a few elements – so they're very versatile, which is why I come back to them from time to time. Decorative patterns aren't that interesting to me. I don't really have a knack for them and don't really consider myself a pattern fanatic. I don't have the

passion for that type of pattern, for wallpaper or sheets or what have you, and there are plenty of people who do and would do a much better job of it anyway. What interests me is the potential to make weird, endlessly looping stories or scenarios. I love the idea of that, and I'm a bit ashamed that I haven't done anything like that yet. You've reminded me that I need to get on that. Thanks!

What do you consider your biggest achievement to date?

RF: I think it's the *Hall of Best Knowledge* book [a collection of 'typographical comics']. Even though I'm kind of sick of it now, that book started me on a path that I think will lead somewhere good. It got me back into drawing and working on my own projects, and opened the door for a lot of fun and satisfying work, so I'm thankful for that. If I hadn't worked on that comic, I'm not sure what I'd be doing today. Something incredibly boring, probably.

Do you feel in any way connected to the design tradition in your own country?

RF: There are a lot of great designers in Canada's history and a lot of interesting contemporary people, like Marian Bantjes. Does that mean there is a design tradition? I don't think so. We certainly didn't learn much about Canadian design history in school. But why would we? All the interesting stuff happened elsewhere.

We do have Robert Bringhurst, though, who is pretty much the god of typographic style, so I think that counts for something. It does for me at least.

Maybe I'm the wrong person to ask, because my interest in design has been more in the margins from the very beginning. That's not a great vantage point to judge from. I just don't see myself as a graphic designer. I would say that when I'm doing client work, I'm a

Opposite, top: *SO. UH. UM.* – pattern (detail). Personal work.
Bottom: *Actor Model* – pattern (detail). Personal work.

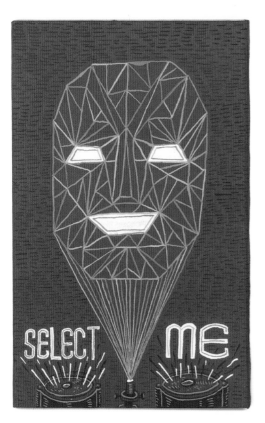

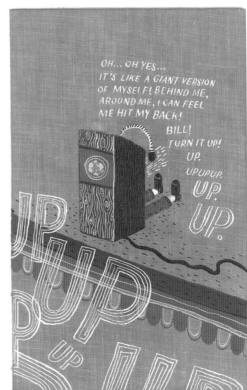

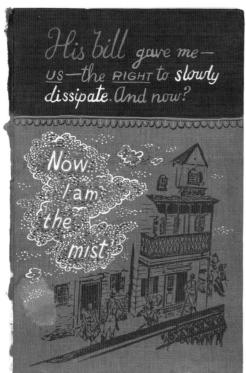

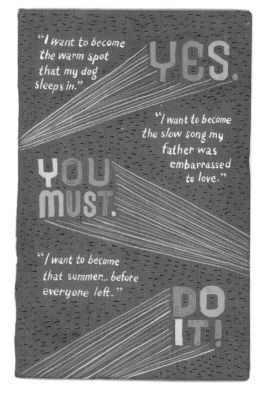

commercial artist or illustrator. When I'm working on my own stuff, I'm an artist. That seems to be the most honest way to describe the situation. But I'd be crazy if I didn't acknowledge the effect my past has had on my current work.

Do you really feel that there is such a clear divide between graphic design and art?

RF: I believe there is absolutely a difference between graphic design and art. Pure design involves a client, and the ideas you're working with are initiated by a client. Pure art does not involve a client, and the ideas are yours. There are lots of confusing areas of overlap, but I think the client thing is a key difference. Does that mean that when designers work on self-directed projects they're artists? Sure. And does it mean that when artists work on commission they're designers? Why not? Who cares? The only time when such stuff really matters is when your aunt asks what it is you do for a living, and you need to give her a short answer. So I say 'artist', and then I say 'most of the time'.

Do you create your personal projects because you can't do those types of work for commercial clients?

RF: Technically 'yes', but clients don't really figure into it for me. It's more about having an idea and wanting to see it realised without any outside constraints or timelines. If I had to find a client for every project I wanted to undertake, I'd never get anything done. Before I went to school, I'd moan about all these people getting to do cool things, having these amazing clients who allowed them to get all weird and loose. I realised later that I was mostly just lazy, because you don't even need clients for that stuff. You can get all weird and loose on your own, and if something comes of it, great, but if not, oh well.

Opposite: *Final Campaign* – four works that are part of a larger series. Personal work.

You seem to be working on such a wide range of projects at the moment. What type of projects do you enjoy the most?

RF: I like the self-initiated things the most. They're a good balance of challenge and reward and they allow for a progression. That doesn't mean I enjoy them throughout the whole process — far from it — but after they're done I feel the most satisfied, and when I look back at them later I often find I like them even more.
I do truly enjoy a lot of client work, especially when the people involved are people I could imagine myself hanging out with, even being friends with. The people who treat you like a service more than a person, those are the clients I could live without. That kind of thing can be tiresome.

Is there anything that you haven't done yet that you would love to do?

RF: Yes! So many things, but a lot of them I'm not skilled enough to do yet so they'll have to wait. I want to write short stories, a book, a play. I want to make weird short films. I want to work on massive drawings and paintings. I want to finish the songs I'm working on. I want to do too many things, all at the same time, which is a real problem. I often wish I was just focused on one thing, because I do admire mastery, but I just wasn't built like that. I think my only true inborn talent is curiosity, so I go in all these directions at once. I'm dedicated to something; it's just not one specific medium.

Interview

Jochen Gerner

Can you tell me what inspired your unique style of drawing?

JG: My graphic style owes a lot to my father, who was my first drawing teacher. He taught me to draw figures in a simplified way and how to prepare small publishing projects. Over time, I have struggled to rid myself of other potential influences that could distract me from those original aims. That's also one of the reasons why I draw in a sketchbook while I'm on the phone. It allows me to create drawings that are spontaneous and produced in a semi-conscious way. Even if I start a drawing with a little logic, my mind very quickly detaches itself to concentrate on my telephone conversation. This mental detachment is what makes the phone project most interesting to me.

Was your father an artist as well?

JG: My father still writes and draws a lot for himself. He was a drawing and art history teacher. All of his artistic preoccupations centred around the expansion of his craft. I think that, today, I have the same rigour in the preparation of projects, the same technique of making notes and sketches, the same passion for books and maps. As a child, I was always leafing through avant-garde and contemporary art magazines that were lying around the house. That influenced me deeply. I produced small, illustrated books; I sculpted and painted wooden objects like Hans Arp; I covered the rocks in the garden in the style of Jean Verame.

Sometimes I meet graphic artists or illustrators who tell me that they had my father as a teacher. His teaching seems to have made a very positive impression on them, too.

You do full-colour illustrations, but also a lot of black and white work. Which technique do you prefer?

JG: I choose colour or black and white depending on the printing technique and the theme of an illustration. I can use colour to complement a black line drawing, particularly for newspaper illustrations. But I always use it with restraint. It's not a question of colouring but of seeing what effect colour has. In the specific case of newspaper illustrations, I often choose to use only a very limited number of colours to avoid weakening the visual effect of the line drawing. However, generally, I prefer

to work in black and white for daily news-papers (printed on newsprint) as I find the result is always more graphically interesting and visually striking.

On the other hand, I love working with colour. It's about finding the right balance so that I give the reader what they need to get the most out of the image.

For my more personal publishing projects, the printing techniques that I have at my disposal generally reproduce the colours of the original artwork more accurately. With that in mind, I love to work directly with poster paint or acrylic to create variations in the texture. When painting with a brush, the elements of the illustration are more freely composed. It's a fairly complex balancing act but that can also lead to more spontaneity.

Over time, I've simplified my drawing style and colouring to move more towards minimalism and synthesis, but the image remains very elabo-rate and detailed. I try to organise my graphic language like an alphabet of pictograms.

On the one hand, as you say, you like to work with the simplicity of the stylised black and white drawing. On the other hand you sometimes create very elaborate illustrations...

JG: I think I'm permanently switching between minimalism and abundance. My lines and figures are simple, but the way these elements work next to each other forms a more complex whole. I'm attached to every single element in my compositions. Each detail of a line is important to me. I construct my images like a story, like comic strips, and that's also the reason why my personal projects often consist of series of images.

So when a client commissions you to do a series of illustrations, is that just as inter-esting for you?

JG: I like creating sequences of pictograms or drawings for newspapers. But for illustrations with a more substantial format, I prefer to work on a single image.

In the case of a newspaper illustration, the image depends heavily on the context. I rely on the content of the article, on the format and on the graphical style of the newspaper to construct my illustration. That way, I don't have the feeling of working in a vacuum. But for personal projects, it's always more difficult to produce a single, unique image.

As an artist you have your own visual language, but you also have to deal with the harsh reality of working for a client. Is this difficult for you?

JG: It depends. Most of the time I work with newspapers and publishers that I have known for a long time. In those cases things go smoothly. For occasional clients, I realise that you have to act with diplomacy but without making too many concessions. Nevertheless, the cooperation between the client and the illustrator will never succeed when there is no genuine understanding of the nature of the project or the specific visual language of the illustrator.

The phone drawings you mentioned before, were collected in your book *En ligne(s)*. Is it a difficult decision to publish sketches that you actually only made for yourself?

JG: I make a lot of preliminary sketches for illustrations and projects, and that part of my work is not published. If sketches are not the centre of a project, but only one step in it, then they are just a working tool that doesn't necessarily have to be shown.

But in 1994 I started drawing little things in a sketchbook while talking on the telephone (as a lot of people do) and I realised that I was drawing strange things because my hand was sketching while my mind was elsewhere. It was only later that a publisher wanted to reproduce the pages of this sketchbook as a book.

Now I always have a sketchbook next to the phone and it has become a sort of personal journal – it witnesses my conversations, my reading and my personal reality. The second sketchbook, *Branchages*, has just been published by L'Association and I'm currently working on a third collection. Each book covers a period of approximately seven to nine years. You can see that the graphics have evolved significantly from the first to the last page. Those sketchbooks have served me as a graphic database where I can search for new line forms and strange characters.

Sometimes I create other sketchbooks based on different constraints. I like setting myself these boundaries and seeing how the drawings evolve from those initial restrictions. For several years I have been drawing everything I see through the window while travelling by train. From this I've produced a book of my railway drawings – *Grande Vitesse*.

A lot of your books, as well as other projects, seem to be about time you spend travelling...

JG: Yes, my first comic strips were accounts of trips. They were put together in a book entitled *Courts-circuits géographiques*. It is practically a journalistic work, an investigation of a given place. I put myself in it as a character but it's mainly an account of things I have seen – not necessarily a simple autobiographical story.

I love to reproduce my impressions but, paradoxically, I'm not a great lover of travel journals. I don't like to draw while travelling (except in a train when I can find a small work table), but I may make a lot of notes. When I'm travelling, I just try to live the experience as much as possible. As a rule, I practically never work on fiction projects (except in collaboration with scriptwriters). Personally, I prefer to hang on to reality and use documentary forms and my scientific or literary knowledge.

I noticed that you like to use other printed matter as a base for your own work. You paint or draw over existing printed pages...

JG: In the beginning, I started with a very simple idea. If white – unused – paper wasn't available, would it be possible to produce images from existing printed pages? It's essentially recycling. This gave me another of those limitations we've been discussing: what to do with an existing printed image and how to change it. I see the printed page as a study subject – a subject for analysis: with my

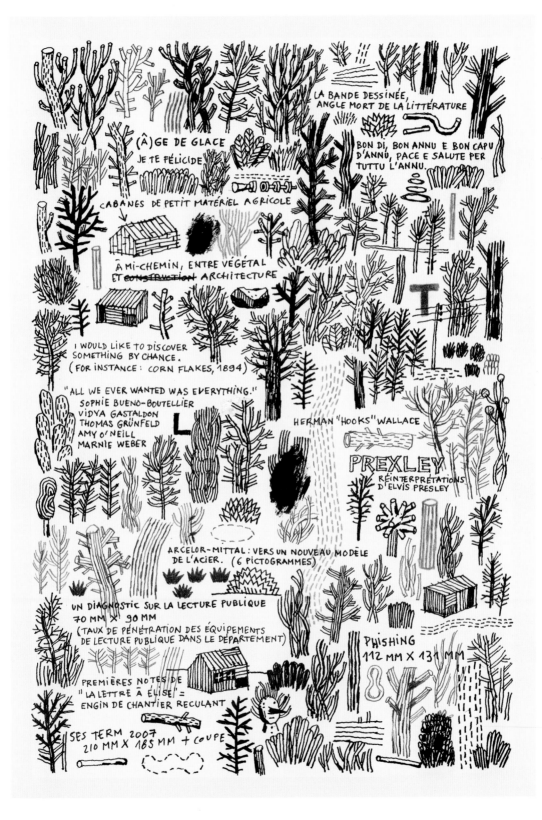

<u>PERSONNAGES</u> : Formes géométriques simples (voir silhouettes)
codes couleurs précis.

<u>ROI</u> (baryton-basse)

NOIR GRIS ROUGE
 CHAUD

trame

La référence à la bande dessinée
doit se faire aussi par les détails
graphiques. le tissu imprimé
(trame + traits de contour)
évoque l'objet bande dessinée :
<u>le livre imprimé</u> (encre et
page blanche).
→référence à l'objet et non
pas à un "esprit bande dessinée".

tissu
blanc

traits
de
contours

Docteur

<u>REINE</u> (soprano dramatique)

NOIR ROSE ROUGE

[Dieu : allure quelconque, habillé
en jardinier.

<u>DIEU</u> (alto)

NOIR VERT VERT
 OLIVE VIF

<u>DOCTEUR</u> (soprano lyrique)

NOIR BLEU ROUGE
 VIF

Reine

Dieu

<u>CHEF DE LA GARDE</u> (ténor de caractère)

NOIR BLEU BLEU
 SOMBRE VIF ?

<u>ÉTRANGER</u> (baryton lyrique)

chef de la
Garde

Roi
(Docteur ?)

Docteur

NOIR GRIS BLANC BLEU
 CHAUD SOMBRE

L'Étranger : "ses jambes sont entravées par une (Étranger)
lanière, et sa tête disparaît sous
des bandelettes."

tissu recouvrant la
structure et la laissant
apparaître

<u>Point de trame</u>
taille réelle
d'impression

le point de trame
doit correspondre
à un <u>point agrandi</u>: déformations.
(trame grossière)

1,5 à 2cm

semi-
transparence

2-3 mètres
de long

- nuages suspendus - CIEL
une structure comme une cage
 (→ cages suspendues
 de Piranèse)
 (→ phylactères)
 (→ "château céleste)
 (→ Dirigeables)

structures
suspendues au-dessus
de la scène

mouvement
éventuel des
nuages

Bottes noires -
Recouvrement en feutre
← code graphique : ligne de couleur ?

graphical intervention, I reflect on the original concept of the image.

The choice of page is very important. I try to create a significant connection between the past and the present. This approach interests me because you have to know just which parts of the printed page to cover. If I cover too much or not enough of the original image, the effect will be limited. It's a question of finding the right balance. That way, it's possible to discover details in the original image and make them communicate something fresh. It's a kind of revelation. I choose to let certain details or colours appear because it seems relevant to me to stress their importance. Each original image leads to a new graphical code of coverage. It is an artistic and conceptual search at the same time.

You designed the costumes and stage sets for an opera based on your comic *Politique étrangère*. What was it like to work on that?
JG: I had drawn this comic strip in collaboration with Lewis Trondheim who wrote the script. When the opera project became a reality, he offered to let me design the sets and costumes. It was interesting to work on this risky transition from the printed page into the third dimension. I had to take a lot of new criteria into account: volume, music, singing, lighting, the director's interpretation... I decided to team up with a costume designer and a set designer who could help me understand the limitations of these disciplines.

The approach we took was to translate the comic strip via its formal and technical aspects. We had frame motifs appearing on the costumes and on each character, and we gave them a very precise form thanks to a system of padding and stays. The accessories and scenery were constructed on the basis of a false second dimension: each object had a flat form, as if cut from a sheet of paper.

I also established a colour chart that discreetly punctuated the costumes and the scenery. My drawings didn't appear anywhere in the sets except for some green plants that were destroyed by a character in the story. I love this ironic detail: the only appearance of drawing leads to its destruction on stage.

I think the final result was true to the spirit of the book and, at the same time, completely different in form. And the spectacle as a whole was very well received.

Which areas do you most enjoy working in and are there any left that you would still like to explore?
JG: I try to alternate between my preferred areas: newspaper illustrations, publishing projects and exhibitions.

I regularly receive requests from art centres or museums to produce illustrations for publishing projects or exhibitions. The commercial assignments allow me to work in a more relaxed way on my less profitable projects. But sometimes I have to refuse illustration work because things don't always turn up at your door at the right time. However, at the moment, it is generally my most experimental and personal projects that are making me a living. And my books and series of drawings have received a warm welcome in the contemporary art scene.

I try to experiment and confront my drawing with areas as different as children's books, comic strips, theatrical production, newspapers and the art scene. I have also cooperated with architects on an architecture competition and I hope that soon I'll be working on specific projects in this area. I guess I try not to get too trapped in any particular environment.

Opposite: a page from a sketchbook with designs for the opera *Affaire étrangère*.

Interview

Max Kisman

In the eighties, while most designers were still pasting everything together, you were one of the first people to experiment seriously with the use of computers. Was the computer just a replacement for your other tools, or were you hoping to expand your artistic possibilities by experimenting with this new medium?

MK: Experimenting it certainly was. It was the computer imagery in those initial music videos that made me wonder how this technology might affect graphic design in print. I bought a Sinclair Spectrum (48K) home computer and used it for crude poster designs. I really started to understand the possibilities of computers when I was commissioned to design a series of Dutch Red Cross postage stamps that were released in 1987. I began to use the computer as a set of digital scissors and I drew straight into the machine. That's when I discovered a certain kinship with people like Matisse, Saul Bass and Jan Bons, among others.

The computer has become the standard of the graphics industry. The impact of those automated processes, for example the control it gives you over the production process, is amazing. But I have never been that interested in the power of the computer. I've never thought that just because computer technology is complex, the way you use it needs to be complex too – all that layering of illustrations and designs that goes on. I tend to do the opposite. If I only draw a single line – and that line supplies an ultimate solution for a design – then I have used the technology perfectly. I think that is where the computer has brought me in the end – to the realisation that expanding possibilities is a mental rather than a technological process.

You have a very recognisable style. Do you feel that this is a hindrance in your cooperation with clients, or an advantage? Does it give you a lot of freedom?

MK: I don't care too much about the freedom I have, or lack of it. Within the limitations, or perhaps I should say in exploring the limitations of an assignment, I can still take liberties. Clients, of course, may approach me for a certain kind of image – perhaps an illustration of mine that they've seen somewhere. But if they ask for a new design, for example a total visual identity package, I don't know beforehand what its style will be.

The aesthetics in my graphic design is less specific than in my illustrations or drawings. I am fascinated with the visual strength of simplified graphic images: the pictographs of the American South West, the graphic symbols of Isotype designed by Gert Arntz, the paper cut-outs of Matisse, Saul Bass and Dick Bruna, the Javanese Wayang Kulit shadow puppets, and the Jip and Janneke characters of Fiep Westerdorp [Dutch children's book illustrator]. It is important to me to always develop a very simple, but clear visual solution. That is my goal and it needs practice and experience. It requires courage and thought. It is a strategy. Ultimately, the final outcome of every assignment depends completely on the brief, the overall circumstances, time restraints and budget limitations.

Do you really make such a clear divide between your design and illustration work? I know that a big part of your work nowadays is pure illustration, but I feel that illustrations were always an integral part in most of your graphic design work as well.
MK: You're right – there is probably no clear distinction between the two in the way that

I work with assignments, whether they're client requests or my own work.
When I was responsible for the TV graphics of VPRO [a Dutch public broadcasting network], the animations and motion graphics were the station's visual identity. The graphics were simple looped 2D and 3D animations of situations, characters and objects, produced on limited budget animation computers. They only carried a voice-over, announcing a particular TV broadcast. The work was design and 'illustration' at the same time. The image – its style, its appearance and how it was communicated – contained within it a concept of both design and imagery. It was easily identifiable. VPRO's identity was my identity, and my identity was VPRO's identity.
My heart, I think, is more engaged in the act of drawing, in generating an image, visualising an idea, a thought or a concept. Drawing is thinking. Although I obviously think when working in both fields, designing is more about honing things, eliminating excessive information. It is about editing out stuff you don't need or want to be 'in the picture'. In a way it is information manipulation. This, of course, also holds true to a certain extent with

drawing, because an image only shows what the artist wants to show. There are choices there, too. It's just the different contexts that give meaning to those choices.

In that sense, I maintain the same approach to all the material I work with: subtracting, simplifying, stylising, reducing.

Was doing more illustration work something you chose deliberately? Or does it simply depend on the projects you are offered?

MK: Possibly. My work is very image driven. I think I tend to look for circumstances where that kind of work finds a stage. But it's not something that I particularly chose. I just look for opportunities and grab them. As a freelance artist you can't be too selective, especially if you want to progress both creatively and financially within your field.

As I said, I use a very similar approach in the various aspects of design and illustration, animation or typography and type design that I work in, so it doesn't make much of a difference what I do.

What do you feel are the main limitations you have when working on an assignment?

MK: Time has become one of the most significant limitations. I can't say exactly why. It might be because of the number of requests I receive, or it might be that I want to work faster all the time. Maybe I just have a limited attention span. For a long time I have been and still am involved in daily, weekly or monthly publications that all have a short-term production process.

Magazines, newspapers, TV stations — these are the environments that I love to work in. As far as their production concerns go, they reflect a certain no-nonsense reality. Whatever you come up with, you must deliver. That, in particular, is the author's responsibility, to deliver quality and professionalism. If, in addition to that, the work is also visually consistent and expresses virtuosity (or easiness, nonchalance), then you have sufficient

mastery to move freely within a lot of limitations. If I am able to move freely within a set of constraints, then I'm still essentially doing my own thing.

One of the things that Dutch graphic design is famous for is postage stamps. You've had the opportunity to design several over the years. Could you tell me something about the process you go through when designing a stamp?

MK: Yes, I have been very fortunate. The development and production process is an interesting experience. Designing a stamp isn't that different from designing a poster — it's just much smaller. Ultimately, a stamp is a poster to look at up close and a poster is a stamp to look at from a distance.

The Dutch Red Cross postage stamps were the first stamps I designed, back in 1986. It was the first commissioned design project I did on a computer and I used a Commodore Amiga 1000. Swapping between digital drawing with paper cut-out collages and manual sketches, I investigated reduction and subtraction in my images. Both approaches added new insights into the results of the other. The technology was still primitive at the time and it was a very laborious process, but in the end I managed to get digitally produced negatives to print. That was a breakthrough.

Later, with my other stamp designs, I had a clearer idea of my own style of images. Nowadays, I manually trace drawn sketches directly within graphics applications to produce the final digital artwork and layouts.

For a long period of time you lived in the US. What was the reason for your move, and has it had any kind of influence on your work?

MK: After working as a graphic designer for

Previous page: photo of Max Kisman © Karin van der Heiden. Opposite, top: *Rode Kruiszegels 1987* – Red Cross themed postage stamps. Client: TNT Post. Bottom: *Tegentonen 1991* – silk-screen poster for a music festival. Client: Paradiso.

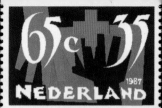
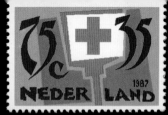

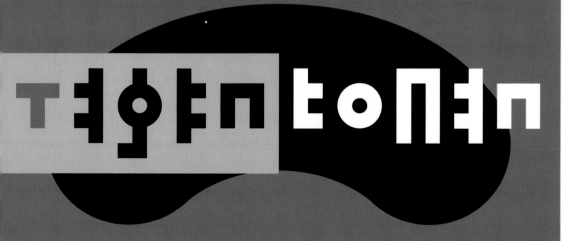

bloedrood vlamt zij op

bloedrood vlamt zij op

de pioenroos in haar haar

de pioenroos in haar haar

te branden lijkt de zee

te branden lijkt de zee

verhitte dromen

verhitte dromen

vrouw in verwarring

vrouw in verwarring

VPRO TV, I was offered a job as design director at Wired TV and Hot Wired in San Francisco. I don't think it changed the content of my work that much. On the other hand, I have become more flexible in the way I approach business processes, collaboration and production. Although I was appreciated professionally, I can't say that my visual language connected that well to a more market-driven American culture, or more specifically, its taste.

You have done a variety of collaborative projects, like *Building Letters*, *Tribe* and the *Dutch Doubles* typeface. It seems to me that, along with doing your own thing, you place a lot of value on interaction with other designers.

MK: I appreciate kinship. I like to relate to my colleagues; I respect them. These projects are career meeting places. It's like saying: 'Hello, how are you?'.
To work with other designers or colleagues requires a mutual appreciation, respect and trust within the professional responsibilities of a particular project. Discussion and communication on a professional level are based on mutual and similar experiences, rather than authority. Authority (in the sense of being knowledgeable) is something I use when I teach students.

You have taught at the Gerrit Rietveld Academy, the school of fine arts in Utrecht, the CCA in San Francisco and the Design Academy in Eindhoven. Can you tell me something about your approach to teaching?

MK: I see teaching as lifting up the veil of mystery and misconception. It is about connecting points of interest and the unknown to points of actual activity in the real world and — in our field — cultural heritage. There is, of course, quite a difference between the current consumption of popular designer products and the cultural heritage and history of design (including graphic design).
Graphic design has evolved technologically, socially and semiotically as well. Digital technology has changed and is constantly changing the landscape of design-related disciplines. Everybody can produce what anybody else is making. Information is a shared domain. The internet connects everything, which is both a blessing and a curse.
But graphic design is not just about producing graphics and typography. It is about thinking — thinking about the use and context of information, about communication in a social, commercial, functional or cultural context. The essence of communication hasn't changed much over the years. Good design reflects an understanding of communication within the context of a sense of beauty. This professional skill is one of the key points that I try to pass on to my students.
Teaching is also about eliminating any expectations of how this profession should be executed by every individual. You should never attempt simply to embody existing examples; you can only work within your own mental and physical limitations. But, at the same time, you have to relate to the history of the field you operate within. To forge their individual place in the world, art students need to master certain skills that suit and exploit their talents as well as their limitations.

Opposite: *Bloedrood* — silk-screen print for *De Zee*, a group exhibition at the Keizer Karel gallery in Amstelveen, the Netherlands. The text is by the Japanese poet Yosano Akiko.

Interview

Andy Smith

Your style seems inspired by the graphic design of past eras, but the final result is something new and refreshing. Where do you get your inspiration from?

AS: I am inspired by all areas of design but some of it just doesn't filter through to the work that I make. For example, there's plenty of design that uses a lot of colour and effects, such as fades, blends and patterns, all of which have obviously been created digitally. I like some of this work but I don't really feel that I want to bring that into what I am making myself, unless I somehow put my stamp on it. I really like the printing in old picture books, when they weren't printed in full colour like they are today but in just a few spot colours. That's a similar look to what I often go for in my work and I think that's where the influence from the past comes in – it's more the printing techniques than any specific artists. Slick design just isn't for me – it's too cold and can be very mechanical. I like work where you can see that the hand has been involved, where little mistakes are made in the drawing and the printing and where you can see that the creator has planned out which colours will be used and how they will interact, rather than just throwing everything in. I simply don't need thousands of zappy colours.

I suppose I have developed my own language and way of tackling a problem and it doesn't feel right to divert from it. It's important to experiment but I don't want to make work that doesn't look like its been done by me. I'm happy to follow this path and see where it takes me.

The atmosphere in your illustrations and designs is, for the most part, determined by a structure reminiscent of the silk-screen process. Is this your favourite printing technique?

AS: I learnt to screen print on my degree course. At the time I was doing a lot of doodles and drawings in my sketchbook and I realised that silk-screen was a good way to develop these sketches into something new while keeping the spontaneity of the original drawings. So I used to blow stuff up big on a photocopier and then print it. This was way before I had used a computer, which I came to later. I learnt all the rules and constraints of screen printing and still keep them in mind when I'm working digitally – so I limit my

colours, allow colour overlaps, use halftones and keep everything nice and bold. It's possible to do almost anything on a computer, so it's good to have some rules that you can react to.

Did you ever try any other graphic techniques, for example etching? Etchings also have that exciting element of surprise in the final print...
AS: Yes, I have tried etching and also lithography, but the thing I like about screen printing is that it's easy to mix mechanical elements like pixelated dots and other effects into a drawing. With the other methods it feels a little too hand-done. Silk-screen printing also feels much more immediate, perhaps because it was developed originally as an industrial print technique. I like the clarity and simplicity that a screen print possesses.

The way you work seems quite spontaneous. Is there always an element of accidental effect in your final work?
AS: I try not to be too precious with my work. If I spend too long on a piece, I tend to fiddle about with details that don't really matter.

I also find that when I draw, the first drawing often turns out to be the best – I suppose because it's the most spontaneous and fresh. For this reason, short deadlines suit me. I'd rather get on with a project than let it drag slowly. Strike while the iron is hot!

Is it difficult for you to decide when a design or illustration is finished?
AS: No, not really. I don't usually work stuff out as I'm doing it but I often have a fairly good idea of what I want to do before I start to work on anything. I've never been one of those people who, when given a brief or problem, will go away and brainstorm it and come up with loads of ideas and sketches and then develop them that way on paper.
I tend to just wander about and think about the problem and find a solution that way, so when I start sketching, I already have a clear idea of what I'm doing. It saves on paper! Once I've got the idea, that's the difficult bit over with – making the image is usually straightforward. However, I do find that when it's done, I will often look at it again and see if it can be simplified and made bolder in some way. I try not to over-complicate an image.

You are doing a lot of book covers. Is this something you always wanted to do?

AS: I always wanted to do posters. My college work was a mix of posters, some animations and some little self-published books. I didn't really do any book cover work until commissions started coming in, mainly because I was more interested in telling my own stories and developing little characters and situations than I was in commenting on someone else's. I think I used to feel it was better to make and show work that was one hundred per cent me in its ideas than fifty per cent me and fifty per cent someone else. Over time, I have become more confident about tackling book jackets and now really enjoy them. They are always a challenge as the briefs are usually so different, depending on the style of book.

Do you have a favourite type of book that you like to design covers for?

AS: Not really. It doesn't seem to follow that the type of book necessarily dictates the type of cover. It's more about the audience that the book is aimed at and what they will relate to and ultimately buy. It's much easier to design a cover for a new book that doesn't come with a lot of already established imagery than a classic with all its baggage. It's also easier if you don't know too much about the genre that the book fits into. For example, if I were to work on a science fiction book jacket, I wouldn't necessarily want to go down the sci-fi route but would want to tackle it in my own way.

Do you get to read the whole book or fragments when you are working on a book cover and how important is that for you?

AS: A lot of the books that I have done covers for are still at manuscript stage when I am asked to do the cover, so the most I get is often a small excerpt or a summary of the plot. I think that's a good time to start work on a cover, as sometimes when you are able to read the whole book, you can get too close to it and it's more difficult to boil down all the information to just one cover image. I think it's good to be a little detached from the subject – an illustrator can have a very different way of looking at things to an author and it's important to keep your own point of view and not get bogged down by the book.

You also publish your own limited edition picture books and you create limited edition prints. How much of your work is made up of projects you initiate yourself?

AS: The projects I've initiated myself are a big part of my work, as they often feed through or influence my commercial work. I try to have one or two projects of my own running alongside any client work I am doing. They are a good chance to experiment with ideas that just don't fit into normal briefs, and to let them develop and see where they go without any pressure. If they don't quite work out, it doesn't really matter. After all, it's good to make mistakes sometimes.

I like designing the books as it's a good excuse to create little stories, situations and characters and I like playing with the way they interact with the reader and the turn of the page. I try to make them all 'me', not just visually in the way they are drawn and created but in the ideas behind them. Over time I have kind of developed my own little world of characters, events and humour. This is my language and way of looking at things and I try to bring that to each new project.

The prints are often experiments with typography or the printing process itself. It's great to design a screen print and then print it yourself. They never print exactly as you plan them and it's exciting to see how they'll turn out.

I like the whole idea of making these little

Opposite, top left: cover for Mario Vargas Llosa's collection of essays *Touchstones*. Client: Faber & Faber. Top right: cover for Joseph Connolly's book *Love is Strange*. Client: Faber & Faber. Bottom left: cover for Rosemary Clement-Moore's book *Prom dates from hell*. Client: Random House USA. Bottom right: cover for Philip Dodd's short story collection *The Reverend Guppy's Aquarium*. Client: Random House.

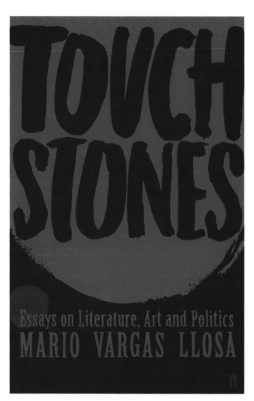

TOUCH STONES

Essays on Literature, Art and Politics

MARIO VARGAS LLOSA

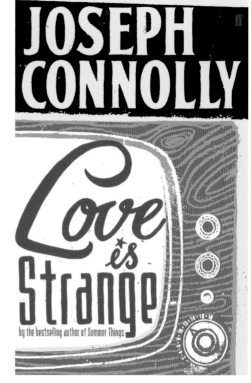

JOSEPH CONNOLLY

Love is Strange

by the bestselling author of Summer Things

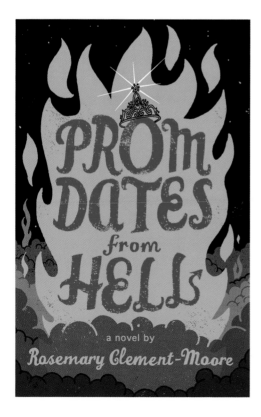

PROM DATES from HELL

a novel by

Rosemary Clement-Moore

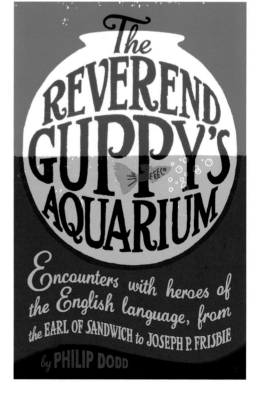

The REVEREND GUPPY'S AQUARIUM

Encounters with heroes of the English language, from the EARL OF SANDWICH to JOSEPH P. FRISBIE

by PHILIP DODD

books and prints for no real reason other than I feel like it, but I think you also need the challenge of working to someone else's brief to give a bit of balance to this.

Are you interested in what others are creating?

AS: Yes, I am interested and I keep an eye on what's happening – with the internet it's very easy to see what's going on globally. It's good to see illustrators branching out and producing products and objects such as books, prints, toys, etc. rather than just making work for clients. I try to keep aware of lots of other forms of art – painting, sculpture, print making, architecture, product design, etc. – as inspiration can come from where you least expect it. I have recently been doing a lot of print making but I'm also quite interested in the third dimension. It would be nice to develop some of my work in that direction. I really like ceramics with their thick, bold colours and glazes – they kind of relate to silk-screen prints, where varnishes can also be used to good effect. Who knows...

Are there any types of clients whose assignments you would refuse?

AS: I think if you're an illustrator, especially one who works in advertising at times, you need to be able to create work for a wide range of briefs. I know that the definition of an illustrator has blurred somewhat, but essentially you are being paid to communicate someone else's message and I think you have to accept that. It would become very difficult if I decided that I would help to promote this product but not that, or one brand over another, so I try to keep an open mind about who I'm working for. I guess if I held very strong views about something, I probably wouldn't work against them but it hasn't happened yet. If I felt that a cause was particularly barmy or extreme I would decline!

In these times it's quite a balancing act as a designer/illustrator to do work for commercial clients and keep your own integrity as an artist...

AS: I like the challenge. One of the things I like about illustration is the whole idea of solving a problem, whether it be a brief for a client or something that I am doing for myself. In many ways that's the most rewarding part, as you're pushing yourself and learning something. Once you've solved the problem in your mind, it's only a matter of making it work on the page, which is much easier if you've already got the right answer. I am lucky in that with most of my commercial work I am able to get involved in the ideas stage and can bring some of my humour and way of looking at things to the job, which is often the interesting part. That's something I really enjoy, as it means I am not an illustrator who is simply told what to draw by a client.

My agent in Paris gets me a lot of great European work and I handle the UK and US work. I enjoy dealing with clients directly as I think if you rely too much on an agent, you become removed from the people you are actually working for. You can end up just waiting for your agent to call and so, in many ways, you are not really in control of what you are doing. I also enjoy the self-promotion side of things and like planning mail outs of posters, books, etc. When I do these kinds of things, I am dealing directly with designers and art directors and it helps to build up a rapport that makes working together much easier.

Opposite: *Warning the monster is loose* – limited edition silk-screen print. Personal work.

Interview

Spike Press

Before concentrating on your illustrations and posters, you were actually designing websites full time. Was it an effort to do something less technical?

JS: It was. When I first started doing posters, I was very much in the vein of 'find cool clip art, then put a cool font next to it', which is roughly what I was doing at my corporate design job. I think a lot of poster designers begin that way. To stand out from the ever-growing crowd, I had to force myself to rely more and more on my illustration and lettering, which made my work more idiosyncratic and was also much more fun and involving for me.

Who or what inspired you to make such a big change?

JS: First of all, I was really bored with my job designing websites – I felt like I was spinning my wheels and had stopped learning anything new as a designer. At the same time, I was seeing a lot of screen-printed posters around Chicago by Steve Walters, Jay Ryan and Kristen Thiele (among others) and immediately knew that's what I wanted to do. I was attracted to it because it offered everything my 'real' job didn't: interesting subject matter,

creative freedom and the opportunity to get my hands dirty.

Was it difficult to start working for yourself, go out there and find clients?

JS: Not really. Bands that need posters are a dime a dozen and I was friends with several people playing in bands, so I started volunteering to print posters for them on the cheap – usually just to cover costs and get a spot on the guest list at the show. As I got requests from more and more bands and promoters, I started thinking that I could turn this 'hobby' into something full-time, so that really spurred me on to work as hard as I could.

It also must have been quite a change to go from working office hours to managing your own time. Do you find it difficult to juggle the different assignments time wise?

JS: Sometimes, but since I enjoy running Spike Press so much more than working in an office, juggling several jobs doesn't seem like a chore. I've tried to use several different applications that help you track projects and hours, but I always end up using Post-it notes and a bulletin board.

Why, in times when the importance of posters as a means of communication is declining, did you decide to concentrate on just that?
JS: Posters are a great vehicle for artists/designers/illustrators to get wide exposure without having to go through galleries or traditional client work – and while it has been declining as a means of communication, it has been growing as a collectible. When I first started printing posters, I could walk down the street and see them stapled to phone poles and wheat-pasted on walls, whereas now – for better or worse – the majority of screen-printed posters end up on a merchandise table at the show, which has changed the way that designers approach them I think. In the past, important information like the venue name and date needed to be large and bold on a poster, but now it's more of a reminder after, when it's hanging on your bedroom wall.

Wouldn't you rather be doing limited edition art prints, so you can have complete freedom, or do you need the drive to create something for someone?
JS: I have done a few art prints, but I like doing posters for bands because you have a common starting point with some of your audience – you can throw in references to lyrics, song titles, etc. So you can work on two levels: first, to create an overall eye-catching design, but also to capture the essence of the band. Also, from a purely paying-the-rent standpoint, people are more likely to buy a poster if their favourite band's name is on it.

Lettering is an integral part of your work and always blends in with the illustration. How important is this for you?
JS: I can't tell you how many posters I've seen where a great idea and/or illustration has been completely ruined by poor type. It is always a goal of mine to seamlessly integrate my illustration with the type so, when you look at the poster, everything is hitting you as a whole.

Where do you get the inspiration for your lettering from?
JS: Literally, everything – packaging, comic books, signage, children's books, Alexander Girard, Art Chantry, Milton Glaser, etc. I tend to be a fan of older typography – before desktop publishing put a million fonts in front of everyone, when designers and illustrators

were hand-lettering more of their work. Usually I start from scratch and try to develop something that is original and appropriate for the project in question. A lot of my lettering begins as doodles in my sketchbook, where I will play with letter forms. Even when I use existing typefaces I will tend to print out the lock-up, then redraw it in order to take off that perfect edge.

When you design posters, do you do that with silk-screen printing in mind?

JS: Ninety-five per cent of my posters are screen printed, so that definitely figures into the design and planning process. It became my preferred printing method because it is the easiest way to mass produce large prints using fairly cheap and easily available equipment. Every printer I know started out on a shoe-string budget in a basement or garage with only a cursory knowledge of screen printing. In turn, I think in an age where every Tom, Dick and Harry has a colour printer at home, people are fans of obviously hand-made art.

Can you tell me something about the process you go through, when producing a poster?

JS: If I am not familiar with the band that the poster is for, I will read up on them or listen to them. What kind of music is it? What is the name of the album they are touring to promote? How do they choose to represent themselves visually on album covers and T-shirts? Often this info will lead to at least a few poster ideas. I will then start with thumbnail sketches — anything I can think of — and this hopefully gets all the obvious, ham-fisted ideas out of the way in my sketchbook. When I hit on something I think is worth elaborating, I will scan the small sketch, print that out, and then rework it at a larger size. At this point, if I want an illustration to have a rough feel, I will ink it by hand and then scan it, but if I want it to have a cleaner, sharp feel, I will scan the rough and redraw it in Illustrator.

How much freedom do your clients give you when designing a poster?

JS: It depends on the client. Some want to spoon-feed you ideas and some want you to come up with everything (which is obviously what I prefer). Sometimes I need to free myself, meaning I will get a job and get an idea in my head that I can't shake — like if the client is more on the conservative, corporate side, I will start to restrict myself, despite the fact that they hired me precisely because my style is not like that.

To what extent is it important that you like the music of the band whose poster you design?

JS: It's always fun to design a poster for a band you are a fan of, but sometimes my style may match a band I really don't like that much. I did a poster for the metal band Mastodon, and it was fun to work outside of my normal, more cartoony, comfort zone.

Which part of creating a poster do you enjoy the most?

JS: I try to integrate my illustration and lettering into the overall design as much as possible, so my favourite part varies from project to project. The printing side has become my least favourite part. Initially, it's pretty great to see something that I have previously only seen at 8.5" x 11" (215 x 280 mm) or on a computer screen come to life in colour at 18" x 24" (457 x 609 mm), but when I am working on the third colour of a 200-poster run, it just seems like time that would be better spent on the design portion. I still print some of my own stuff, but I farm out just as much these days.

Yet initially your offering to clients was that you were responsible for printing your posters. Was it to be able to create something from the sketch through to the final result?

JS: Well, it sort of began the opposite way —

Opposite: *Chicago Blues Fest 2009* – silk-screen poster. Client: Poster Plus.

PracticeSpace PRESENTS

APOSTLE of HUSTLE

WEDS JUNE 13 2007 w/ MEMPHIS & OLA PODRIDA WEDS JUNE 20 2007 w/ BRONZE & THE BITTER TEARS WEDS JUNE 27 2007 w/ ALLA'

 wluw 88.7 *UR*CHICAGO MAGAZINE SCHUBAS SOUTHPORT & BELMONT schubas.com www.spikepress.com PRESS

I learnt how to screen print and then started looking for bands and other clients who wanted posters. And yes, there is a very satisfying feeling that comes from taking something from sketch to print, along with the craft of screen printing, which turns out to be a constantly enjoyable struggle. Most of the printers I know are always refining their techniques, trying new equipment and experimenting with the medium.

At what point in your life did you get interested in lettering and graphic design in general?
JS: Probably as a nine-year-old kid eating cereal with Tony the Tiger staring at me from the box while I watched Bugs Bunny and read *Mad Magazine*, while tracing from *How to Draw Comics the Marvel Way* [an instructional book about how to draw superheroes]. As a kid (and to this day) I was sort of fascinated by the kind of illustrator who can draw the human form in a convincing way, which I guess explains my continuing fascination with comic books.

Those first inspirations still seem to filter through in your work. Is this an aesthetic choice, or a case of youth sentiment?
JS: I think it's both. Although I was born in the late sixties, I had older brothers and sisters, so most of the books and printed material in the house was from the late fifties and early sixties. I am a very visual person and grew up on a steady diet of cartoons and comic books. I think styles from that era are so deeply etched in my brain that sometimes I can't even pick out the influences until someone points it out to me. I never set out to be a certain type of illustrator, but when you look at a certain style for long enough, you pick up the nuances that make it unique.
I think a lot of artists/designers/illustrators end up working in styles they excel in, but not

necessarily the styles they pursued in the first place. For instance, growing up, I was convinced I was going to be a superhero comic book illustrator – go figure. The twelve-year-old comic book nerd in me would love to do something for Marvel comics, but I'm not holding my breath...

It seems you are doing more and more work outside posters. What direction(s) would you like your work to go in?
JS: There are a lot of things I would like to do: children's books, environmental graphics (murals, signage, etc.), character design for animation... I think children's books are the next thing I want to tackle, so I can more fully explore the story-telling aspect of my poster designs. I would want to tell a story with as little text as possible, allowing the illustrations to convey the subtleties of the story.

Do you ever want to return to designing websites?
JS: I still do website design on the side to help with the bills, but I don't think I would want to do it full-time again. That being said, I actually enjoy it more now than I did when I was doing it as a living. Every once in a while, I get to do both illustration and web design – I've just finished working on a site for 826 Chicago [www.826chi.org], which is a non-profit organisation founded by author Dave Eggers [publisher of McSweeney's] to promote creative writing for students. I got to illustrate portions of the site, which looks like a spy cartoon from the sixties.

Opposite: silk-screen poster for a concert of the Apostle of Hustle. Client: Schubas.

Interview

Henning Wagenbreth

Your designs and illustrations are often complex but you have a simplified drawing style. Do you feel that this helps with the interpretation of your work?

HW: Yes, absolutely. I always think it should be possible to decipher an image quickly and easily, and I strive for the greatest possible degree of clarity and simplicity in my drawings by reducing the images to basic geometric shapes. The geometric rigour may be hidden in the composition, but its purpose is absolutely vital: to make the image abstract, to make it into a sign. I draw figures with incorrect proportions and I use distorted perspectives, all to emphasise that my illustrations are not intended to be a reflection of real life. Having said that, I do want the content to refer to reality.

Don't you feel that the world you present in some sections of your work could be perceived as scary and unfriendly and maybe even weird?

HW: In California, a person once asked me if I really created my drawings without the aid of drugs. But I actually don't see my images as that dark. It all comes down to what we think of as 'beauty'. Beauty as an aesthetic category is very complex and dialectic. It's not just the content of so-called beauty magazines – the ugly, funny, tragic and magnificent all belong to it as well. If you deny that, then the end product will only be kitsch. Perhaps I use my vocabulary of forms as a filter to keep away people who don't understand that. Personally, I think that my figures are still too normal and I wish I could leave anatomy, physics and logic even further behind me. Of course, it's difficult to think, let alone draw, outside of the rules that you've been taught. I've been working on an illustration machine [Tobot] for a long time, one that – although it combines images and text according to certain rules – does so without using logic. A lot of great ideas only occur when you switch off your consciousness and move away from ingrained thought patterns. You could achieve this by means of drugs – but that's just too unhealthy in my opinion. So I let my machine, which doesn't have any consciousness to begin with, do the work. I've still got quite a bit to learn from the machine though.

You seem inspired by comics. Not only your style, but the construction of your work also often resembles pages from comics...

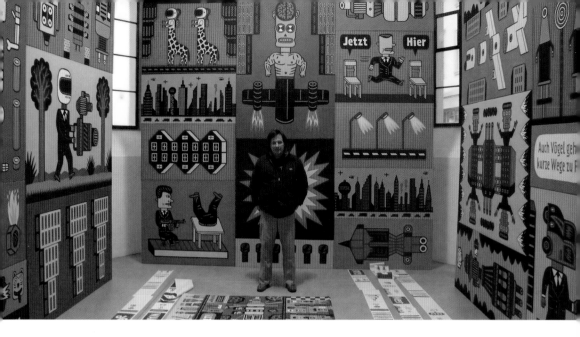

HW: I like drawing letters as much as pictures – that's definitely one of the attractions. I also like the fact that comics are not seen as art. Comics, books and CDs have to be easily available and at a reasonable price. But also, as far as their design elements are concerned, I think comics are the most complex type of art on paper. They combine image and text, drawing, litera- ture, theatre and cinema, sound and music. The interesting thing is that it's not actually possible to depict the dimensions of time or sound on paper, but there are visual signs that can be used to indicate these concepts. A story is then created in the head of the reader, just as a film with a sound track. That's what makes comics an interactive medium – the reader has to generate the various moods, situations and movements in his own head.

A vast amount of information is condensed in comics. I like the intensity of colours and contrasts, distorted perspectives and speed. I'm fascinated by how images and letters collide, how meaning is created, twisted and then destroyed again. This all happens within the confines of the narrative and yet at a high level of abstraction, as the things that are described are not actually there.

You mentioned that you like intense colours. How do you choose colours, and what role do they play for you?

HW: In October 2008, I attended the lighting rehearsals for my first stage set (in Lucerne). The set was already very colourful in natural light. But when the head lighting technician then began to light the individual scenes with colourful light, it took my breath away. I had never witnessed such an intensity of colour. All printed and painted colours seemed grey in comparison. Maybe I'm a colour junkie! I certainly have a history with colour. Before I studied applied graphics at art school in Berlin, I had the opportunity to work as an intern at the printing shop Druckerei Graetz. It was a small place, but still very important to East Berlin and many very good graphic designers had their posters printed there. Some printing was done from colour charts, but colours were also mixed by hand to match more adventurous colour samples. I remem- ber how someone once presented some mouldy tree bark and wanted the print of his graphic to match the colour of the bark. The thing I found most exciting was how colours could be mixed using overprinting.

I often took the spoiled proof sheets home with me and later used some of the accidental colour combinations for my own posters. Unfortunately, today printing is usually only seen as a means of reproduction. That's so boring! Nowadays, it takes considerable skill in the art of persuasion, and often more money, to print custom colours. Luckily, functions have been incorporated into graphics and image editing software so that colours can still be used in a highly experimental way and also properly simulated on screen to check what it will look like in print.

My use of colour is often in complete contrast to what one might expect to see with the topics depicted. But our perception of colour only follows the conventions we have been taught – and we pick it up early on, starting with the first children's books we read. Yet, why shouldn't something happy and funny be presented in grey scale or something sad in colour? That's when the result achieved becomes interesting, as far as I'm concerned.

You recently illustrated a book called _1989_. Can you tell me something more about your involvement with this project?

HW: To mark the twentieth anniversary of the fall of the Wall, I was asked by the Italian publisher Orecchio Acerbo to illustrate a book with various short stories about walls in general. The problem was that I had to accept the assignment before I was able to read the stories, and that's something I usually don't do. But the publisher had published very nice books in the past and I already had a certain type of illustration in my head that I wanted to try. And so I said yes. The book features many powerful texts and the authors successfully approached the topic from various angles. However, we also argued about details such as exactly what type of caps Soviet soldiers wore. As I pointed out, this is something I am perfectly well qualified to know. As children, we quite often went on field trips to the barracks of the Soviet army.

Is the whole East/West divide something that still plays a part in your life and how much, if at all, did it influence your work?

HW: The fact that I grew up in East Germany has, of course, formed me. I think I was maybe five years old when I stood at the Brandenburg Gate for the first time and my parents told me: the West is over there, but we are not allowed to go any further. In the distance, the golden Victoria on the Victory Column was visible. Later, it was very formative for me to read politically forbidden books. During my school holidays, I travelled through Poland, Czechoslovakia and the Soviet Union, where I experienced nature in all its beauty and foreign culture, but I also saw former concentration camps and the old Führer Headquarters. While I was in the army, the first strikes organised by the Solidarity trade union began in Gdansk. That was not very far from where I was stationed. People discussed whether the 'brother armies' would come to the aid of the Polish government as they had in 1968 in Prague. Without doubt, this has all been an influence on me. I honestly can't say what I would be drawing today if, as a child, I had spent my summer holidays in the Mediterranean.

Did the fall of the Berlin Wall open up more professional opportunities for you?

HW: Yes, of course. Before I visited West Germany for the first time, I went to Paris. Jacques Lang, who was the French Minister of Culture at the time, had invited East German artists to exhibit in La Villette in Paris. Two whole plane-loads of authors, painters, punk rockers and filmmakers were flown to Paris. We had a large exhibition over several thousand square metres and there was huge interest in what was happening behind the Berlin Wall. For me personally, the encounter with French illustrators and publishers was very important. For the first time, I saw that

Opposite: illustration from the book _1989_. Published by Orecchio Acerbo.

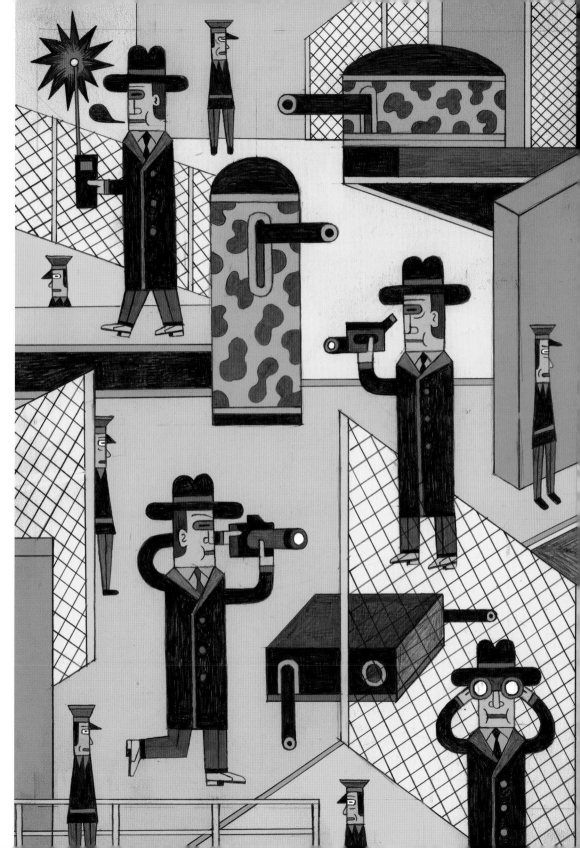

Gastronomen fordern, Vergiftete müssen ab sofort Hüte tragen.

Alle Raucher denken, auch Taschendiebe sollen auf Staatskosten neue Gene kaufen.

Auch wenn es niemand hören will, Analphabeten dürfen täglich Schokolade essen.

Frauen denken, Musiker müssten einmal im Leben in den Untergrund gehen.

Statistiken beweisen, Kleingärtner sollten nichts als ihre Briefe verbrennen.

Alle Großväter fordern, Kriegsverbrecher müssen endlich Kniebeugen machen.

Korrespondenten melden, Wohlhabende dürfen ab sofort Atomwaffen besitzen.

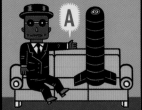

Es bestehen keine Zweifel, Roboter müssen endlich Hosen tragen.

Mütter hoffen, Kinder brauchen keine Schatten werfen.

Die Armee befürchtet, Insekten könnten morgen die Revolution ausrufen.

Die Opposition verlangt, Krankenschwestern müssen rückwirkend kugelsichere Westen tragen.

Die Regierung fordert, Bakterien sollten nur mit Tränen in den Augen Bestechungsgelder annehmen.

Die Polizei macht sich Sorgen, Anarchisten könnten lachend auf den Tisch hauen.

Fußgänger denken, Unfallopfer dürfen sonntags Streit suchen.

Jugendliche befürchten, Arbeitslose werden rückwärts über Steine stürzen.

RRR

Jeder weiß, Konservative können besser auf Bäume klettern.

Ja, auch Maschinen sollten langsam Demut üben.

Ärzte warnen, Pazifisten könnten vor dem Sex die Seiten wechseln.

Es lässt sich nicht mehr vermeiden, Nutztiere müssen ab sofort Lohnkürzungen hinnehmen.

Es ist an der Zeit, Babys sollten einmal im Leben Erdöl fördern.

illustrators can deal with serious topics, that comics don't necessarily have to be funny and can have both dramatic and tragic depth. A year later I moved to Paris. That was a very exciting and formative period. In Paris in 1990, I created my first drawings and a few animations on an Apple computer. As far as my work goes, the invention of the computer was definitely as important as the fall of the Wall.

You have been teaching visual communication at the University of the Arts in Berlin for over 15 years now. Tell me about your work with your students.

HW: I'm responsible for the illustration class. The teaching model we use is taken from the old Prussian art academy, where students would go and be tutored by the master of a certain field. This may seem old-fashioned, but it's got many advantages too. Over a number of terms, the students work together on a project and, in this way, learn just as much from each other as from their professor. The younger students learn from the older students, of course; but the opposite is also often the case. In art, renewal and innovation are often stimulated and introduced by people lower down the hierarchy – and that's true of other walks of life as well. Education is all well and good, but it can also obstruct and restrict objectivity on certain matters.

I don't have a syllabus as such. We move from discipline to discipline just like nomads in the steppe move from one grassland to the next. We deal with books, newspapers, comic strips, posters, animation films, three-dimensional projects... Teaching and learning should never be a one-way street. The subject area and the project tasks materialise over the course of the project. We want to experiment. After all, if everything is already set out beforehand, there is no need to start a project in the first place.

Opposite: comic page for the German edition of the newspaper *Le Monde diplomatique*. The comic was assembled with the help of Wagenbreth's automated illustration system Tobot.

What role do you think a designer or illustrator can really play in solving global problems such as war, racism and the environment?

HW: Designers can only name, record and expose these problems. In the German Democratic Republic, there were no environmental problems because it was forbidden to point these out. I see similar things happening in the world today. Those who point out problems are often ignored, slandered, put off or, and in the case of some countries, even put in prison.

Of course, human nature also says that it's fun to watch the end of the world! It's exciting to follow developments in political conflicts, technical meltdowns, environmental disasters, and so on. Our media industry has based its entire business on this – only bad news is good news. This used to be referred to as 'global theatre'. Even going back to the Renaissance, artists preferred painting hell rather than heaven.

The world's problems often seem to resolve themselves before we have even understood them or sometimes even before we noticed them. An artist is only a spectator and can maybe briefly expand the subject that he is currently observing into the future. The particular hell that he is depicting can perhaps be seen as an appeal to the public to stop the event in question. I don't want to act as an admonisher. But if I do have to be one, then I want to be an entertaining one. Otherwise nobody will pay any attention.

Artist Profiles

Atelier René Knip

www.atelierreneknip.nl
info@atelierreneknip.nl

[EN] René Knip was born in Hoorn, the Netherlands. He began studying painting and graphic arts at the St Joost school of fine arts in Breda in 1985, but in 1987 he switched to the graphic design department, graduating in 1990. After first working as an assistant to the celebrated Dutch designer Anthon Beeke, he started his own studio under the name Atelier René Knip. His design of the *Dutch Design* annual, in 2000, received considerable attention thanks to the imaginative custom lettering on the cover of each volume. As well as his print work, Knip is involved with architectural and environmental graphics, which currently make up seventy per cent of his work. Together with his brother, under the name Gebr. Knip, he has produced a unique series of typographic objects.

[DE] René Knip, geboren im niederländischen Hoorn, studierte ab 1985 Malerei und freie Grafik an der Academie van Visuele Kunsten St. Joost in Breda, wechselte 1987 in den Grafikdesign-Fachbereich und schloss sein Studium 1990 ab. Nachdem er zunächst als Assistent des bekannten niederländischen Designers Anthon Beeke gearbeitet hatte, eröffnete er ein eigenes Studio, das Atelier René Knip. 2000 machte er mit der Gestaltung des *Dutch Design* Yearbook dank der fantasievollen, eigens entworfenen Schrift auf dem Titelblatt jeder Ausgabe auf sich aufmerksam. Neben Typografiegestaltung befasst sich Knip auch mit Grafik im Kontext von Architektur und Umwelt, was momentan 70 Prozent seiner Arbeit ausmacht. Zusammen mit seinem Bruder hat er unter dem Namen Gebr. Knip eine einzigartige Serie typografischer Objekte entworfen.

[FR] René Knip est né à Hoorn, aux Pays-Bas. Il commence par étudier la peinture et les arts graphiques à l'Académie des Beaux-Arts St. Joost de Breda en 1985 pour se tourner, en 1987, vers le design graphique dont il obtiendra un diplôme en 1990. Après avoir débuté sa carrière comme assistant du célèbre designer néerlandais Anthon Beeke, il crée son propre studio, l'Atelier René Knip. La maquette de couverture qu'il réalise pour la parution annuelle des volumes du *Dutch Design* en 2000, lui vaut une attention considérable, grâce à un lettrage personnalisé et créatif. Parallèlement à ses prints, Knip consacre 70 pour cent de son temps au graphisme architectural et environnemental. En collaboration avec son frère, il a réalisé une collection unique d'objets typographiques sous le nom de Gebr. Knip.

[ES] René Knip nació en Hoorn (Países Bajos). Inició estudios de pintura y artes gráficas en la Escuela de Bellas Artes St Joost de Breda en 1985, si bien en 1987 decidió pasar al departamento de diseño gráfico, donde se graduó en 1990. Tras comenzar su andadura profesional como ayudante del célebre diseñador holandés Anthon Beeke, fundó su propio estudio bajo el nombre Atelier René Knip. Su diseño del anuario *Dutch Design* en 2000 recibió una atención considerable gracias al imaginativo rotulado de la portada de cada volumen, con un diseño personalizado. Además de su obra impresa, Knip trabaja con gráficos arquitectónicos y ambientales, que en la actualidad representan el 70% de su obra. Junto con su hermano y bajo el nombre de Gebr. Knip, ha producido una serie exclusiva de objetos tipográficos.

◄◄
Environmental graphics for the Kunst-halcafé in Rotterdam, the Netherlands. Client: Merkx+Girod Architects.

▲
Dutch Design annual 2000-2001. Set of seven books (four shown). Client: BNO/BIS Publishers.

►
Fenceless – art project for the *Armour, the fortification of man* group exhibition at Art Fort Asperen, the Netherlands.

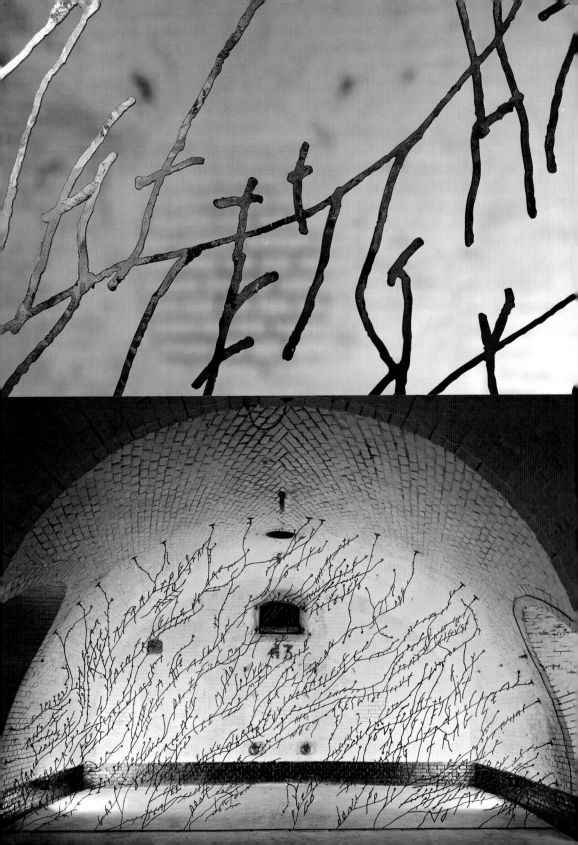

VIERDE SYMFONIE
VRIJDAG 24 SEPT 2004
CONCERTGEBOUWORKEST
DANIELE GATTI, DIRIGENT
GIANLUCA CASCIOLI, PIANO
WERKEN VAN WEBERN,
SCHUMANN EN BRAHMS
BRAHMS
ING | Philips
KAARTVERKOOP 020 671 83 45 » WWW.CONCERTGEBOUWORKEST.NL

JANINE JANSEN
DON 28, VR 29 EN ZON 31 JAN 10
CONCERTGEBOUWORKEST
MARISS JANSONS
ING | PHILIPS WERKEN VAN SIBELIUS EN RACHMANINOFF
TEL 020 671 83 45 » WWW.CONCERTGEBOUWORKEST.NL

COLORS OF SHENG CRIMSON
DON 6 EN VRIJ 7 OKT 05
CONCERTGEBOUWORKEST
DAVID ROBERTSON, DIRIGENT
TOMOKO MUKAIYAMA, PIANO COLIN CURRIE, SLAGWERK
WERKEN VAN STRAVINSKY, ANDRIESSEN,
SHENG EN HINDEMITH
ING | PHILIPS
TEL 020 671 83 45 » 0900 0191 » WWW.CONCERTGEBOUWORKEST.NL

LANG
CONCERTGEBOUWORKEST
DON 15 EN VR 16 OKT 09
LANG
TAN DUN, DIRIGENT
LANG LANG, PIANO
WERKEN VAN TAN DUN
EN DEBUSSY
ING | PHILIPS
TEL 020 671 83 45 » WWW.CONCERTGEBOUWORKEST.NL

Four out of an ongoing series of posters for the Royal Concertgebouw Orchestra in Amsterdam, the Netherlands.

Cast aluminium house numbers designed for Merkx+Girod Architects, to be given away as an anniversary gift.

Four examples of applications of fonts that are part of *ARKTYPE* – a collection of 26 architectural fonts. www.arktype.nl

▼
Cast aluminium office clock. Produced
by Gebr. Knip. www.gebrknip.nl

►
Laser-cut fire basket with 24 one-word
poems written by René Knip. Produced
by Gebr. Knip.

in de lucht hangen. pizzicato.

nabije woorden en zinnen zijn zo n

de wij er koning en koningin! koper van urland naar

eschadigd kunnen worden. lees dit n

en oogwenk uit al kwaad. o nee? h

www.gebrknip.nl

◄
Letterlamp. Each lamp comes with 70 different characters, so that users can set their own text. Produced by Gebr. Knip.

▲
Cube calendar. Elected best Dutch calendar of the last 50 years. Client: Calff & Meischke printers.

Jordan Crane

www.reddingk.com
zzz@reddingk.com

[EN] Jordan Crane grew up in Long Beach, California, but currently resides in Los Angeles. He has always combined graphic design and drawing with publishing activities, starting with editing and illustrating his college newspaper and later publishing his own work and that of others through his Red Ink Press. Crane was editor, designer and contributor to the now defunct comics anthology *NON*, for which he won several AIGA 365 awards. After *NON*, for a time he designed the *MOME* anthology for Fantagraphics Books, which is also the publisher of Crane's graphic novels and his ongoing comic series *Uptight*. In 2007 a selection of his limited edition silk-screen prints and other illustrations were collected by Chronicle Books in a postcard book under the title *Uptight All Night*.

[DE] Jordan Crane wuchs im kalifornischen Long Beach auf und wohnt zurzeit in Los Angeles. Schon immer hat er Grafikdesign und Zeichnen mit dem Publizieren kombinierta; anfangs gab er die Schulzeitung an seinem College heraus und illustrierte sie, später veröffentlichte er eigene und auch fremde Arbeiten in seiner Red Ink Press. Crane war auch Herausgeber, Designer und Autor der inzwischen eingestellten Comic-Anthologie *NON*, für die er mehrere AIGA 365 Awards erhielt. Nach *NON* gestaltete er eine Zeit lang die *MOME*-Anthologie für Fantagraphics Books, bei denen auch Cranes Graphic Novels und seine Comicserie *Uptight* erscheinen. 2007 erschien bei Chronicle Books eine Auswahl seiner Illustrationen und limitierten Siebdrucke unter dem Titel *Uptight All Night* in einem Postkartenbuch.

[FR] Jordan Crane a passé son enfance à Long Beach, en Californie et réside aujourd'hui à Los Angeles. Depuis l'édition et l'illustration du journal de son université et la publication, par la suite, de ses propres travaux ainsi que de ceux d'autres artistes via la Red Ink Press, dont il est le fondateur, il a toujours su combiner l'art du graphisme et du dessin à celui de la publication. Il est également fondateur, éditeur, concepteur et collaborateur de feu l'anthologie de comics, *NON*, pour laquelle il a été récompensé par plusieurs AIGA 365. Après *NON*, il signe pendant un certain temps le design de *MOME*, la nouvelle revue de Fantagraphics Books, chez qui il publie également ses romans graphiques et son recueil trimestriel de comics *Uptight*. En 2007, Chronicle Books publie une série de cartes avec des reproductions de posters sérigraphiés en édition limitée rassemblées dans un étui sous le titre *Uptight All Night*.

[ES] Jordan Crane es originario de Long Beach (California), pero actualmente reside en Los Ángeles. Siempre ha compaginado el diseño gráfico y el dibujo con sus actividades editoriales, empezando por la edición e ilustración del periódico de su universidad y continuando por la publicación de su propia obra y de la de otros a través de su editorial, Red Ink Press. Crane trabajó como revisor, diseñador y colaborador de la hoy difunta antología de cómics *NON*, que le valió diversos premios AIGA 365. Después de *NON* diseñó durante un tiempo la antología *MOME* para Fantagraphics Books, editorial con la que también publica sus novelas gráficas y su serie de cómics *Uptight*. En 2007, Chronicle Books recopiló una selección de sus serigrafías de edición limitada y otras ilustraciones en un libro de postales titulado *Uptight All Night*.

◄◄
Hold the Ground Down – limited edition silk-screen print.

▲
Uptight All Night – cover for a collection of 30 postcards. Published by Chronicle Books.

►
The Shade of Night Falls – limited edition silk-screen print and cover illustration for the comic book *Uptight*.

◄

Someday You're Gonna – limited edition silk-screen print and cover illustration for the summer reading issue of the US-based *Atlantic Monthly*.

►

Wine label. Client: Amelle Wines.

▲
Cover for the US-based *Craphound,*
a magazine filled with clip art.

▶
Derby Dolls – poster for roller derby
event.

L.A. DERBY DOLLS
Saturday, Jan. 26th--6p.m. door

FIGHT CREW versus TOUGH COOKIES

LA'S ORIGINAL ALL-GIRL BANKED TRACK ROLLER DERBY LEAGUE　　　**21 AND OVER ONLY**

1910 W Temple St, Los Angeles, CA 90026　•　tickets at the door or online　•　www.derbydolls.com /la

◄

Light for Dark – limited edition silk-screen print.

▲

Cover for Michael Chabon's book *Maps and Legends*. Art director: Eli Horowitz. Client: McSweeney's.

Piotr Fąfrowicz

tutek1@yahoo.pl

[EN] Piotr Fąfrowicz was born in Szczecin, Poland. He studied History of Art at the Lublin Catholic University before moving to Warsaw where he completed a course in animation. His paintings are characterised by small, faceless figures set against a backdrop of landscapes and buildings. They evoke the atmosphere of medieval miniatures and have an illustrative quality about them. Fąfrowicz has designed many postcards and calendars for publishers and other institutions. His colourful style lends itself easily to children's books, of which he has illustrated six. In 2003 he was one of the founders of the now defunct children's book publisher FRO9. Fąfrowicz's books have received awards in Poland and abroad. He divides his time between Lublin and his second home in Kazimierz Dolny.

[DE] Piotr Fąfrowicz, geboren in Stettin, Polen, studierte Kunstgeschichte an der Katholischen Universität Lublin und zog dann nach Warschau, wo er einen Studiengang in Animation absolvierte. Seine Bilder zeichnen sich durch ihre kleinen, gesichtslosen Figuren vor Hintergründen wie Landschaften oder Gebäuden aus. Mit ihrem illustrativen Charakter erinnern sie atmosphärisch an mittelalterliche Miniaturen. Fąfrowicz hat viele Postkarten und Kalender für Verlage und andere Auftraggeber illustriert. Sein farbenfroher Stil passt auch zu Kinderbüchern — sechs hat er bisher bebildert. 2003 gründete er mit einigen Partnern den inzwischen nicht mehr bestehenden Kinderbuchverlag FRO9. Fąfrowiczs Bücher sind in Polen und anderen Ländern ausgezeichnet worden. Er lebt in Lublin und an seinem Zweitwohnsitz in Kazimierz Dolny.

[FR] Originaire de Szczecin, en Pologne, Piotr Fąfrowicz s'installe à Varsovie où il étudie l'animation après avoir suivi des cours d'Histoire de l'art à l'Université catholique de Lublin. Sa peinture se caractérise par de petits personnages sans visage se détachant sur un fond de paysages et d'édifices. Son style résolument illustratif évoque l'atmosphère caractéristique des miniatures médiévales. Fąfrowicz a réalisé de nombreuses cartes postales et calendriers pour l'édition et la presse. Son style coloré se prête particulièrement à l'illustration de livres pour enfants (six à son actif). C'est l'un des fondateurs, en 2003, de feu la maison d'édition jeunesse, FRO9. Ses livres ont été couronnés par de nombreux prix en Pologne et à l'étranger. Fąfrowicz partage son temps entre Lublin et sa résidence secondaire de Kazimierz Dolny.

[ES] Piotr Fąfrowicz nació en Szczecin (Polonia). Estudió historia del arte en la Universidad Católica de Lublin antes de trasladarse a Varsovia, donde realizó un curso de animación. Sus pinturas se caracterizan por pequeñas figuras sin rostro recortadas sobre un fondo de paisajes naturales y urbanos. Evocan la atmósfera de las miniaturas medievales y tienen una cierta aura de ilustración. Fąfrowicz ha diseñado multitud de postales y calendarios para editoriales e instituciones. Su estilo colorido se presta fácilmente a los libros infantiles, de los cuales ha ilustrado seis. En 2003 fue uno de los fundadores de la hoy desaparecida editorial infantil FRO9. Los libros de Fąfrowicz han sido reconocidos con varios galardones en Polonia y también en el extranjero. Fąfrowicz vive a caballo entre Lublin y su segunda residencia, situada en Kazimierz Dolny.

Kazimierz in November – gouache painting (detail).

Snowman – illustration for the book *Zielony, Żółty, Rudy, Brązowy*. Published by Media Rodzina.

Tango or salsa – gouache painting.

Tango lub Salsa
Piotr Fąftowicz

jesień

Autumn – gouache painting. *Spring Courtyard* – gouache painting.

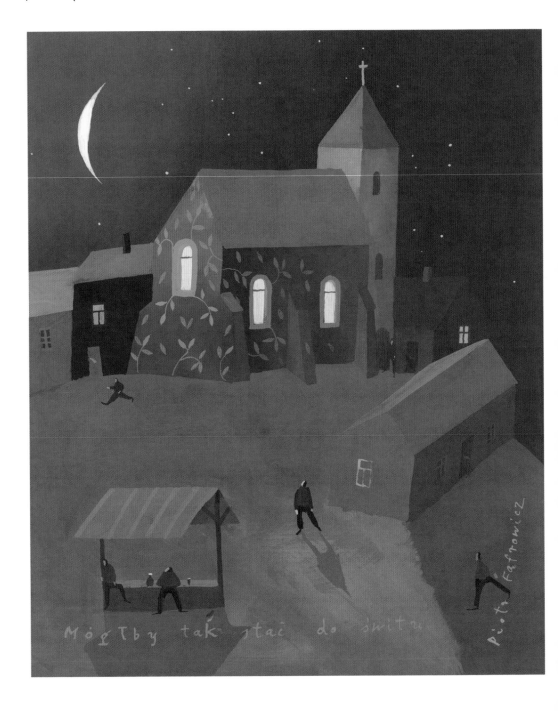

He Could Stand Like This Till Dusk –
gouache painting.

Walking Through the Nocturne –
gouache painting (detail).

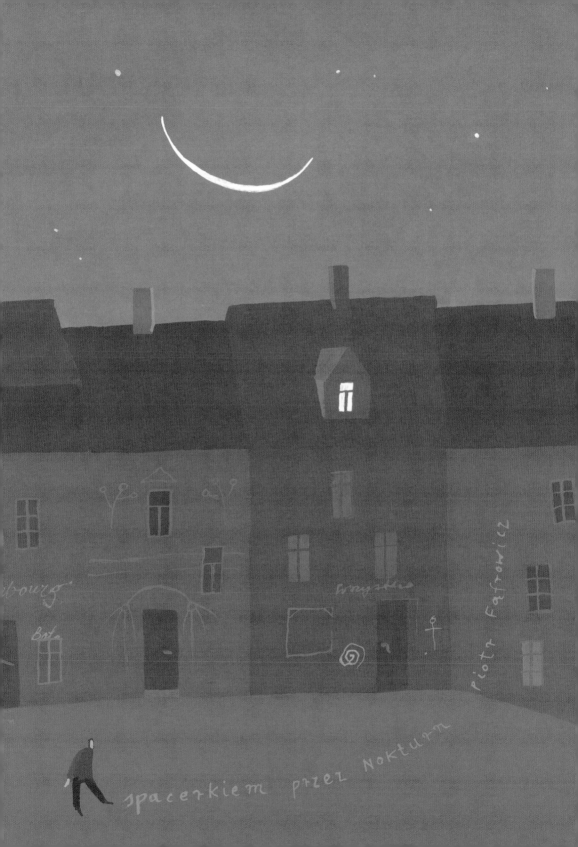

spacerkiem przez Nokturn

Piotr Fąfrowicz

Ray Fenwick

www.rayfenwick.ca
hello@rayfenwick.ca

[EN] Ray Fenwick is a Canadian illustrator, lettering artist and painter. Combining all these skills he creates bags, T-shirts, prints, comics and many other items. A former improv comedian and theatre school dropout, Fenwick gained notoriety for his 'typographical comics' entitled *Hall of Best Knowledge*, which he created for *The Coast* magazine. In 2008, Fantagraphics Books collected all episodes of the series in book form. Alongside his work for a wide range of clients, including Nickelodeon, *The New York Times*, Pentagram, Random House and Urban Outfitters, Fenwick continues to create typographical comics for the *MOME* anthology. In 2009 he designed and illustrated a postcard book under the title *Hi* for Chronicle Books. He lives and works in Halifax, Nova Scotia, Canada.

[DE] Ray Fenwick ist ein kanadischer Illustrator, Schriftkünstler und Maler. Diese Fähigkeiten kombiniert er, um Taschen, T-Shirts, Drucke, Comics und vieles andere zu kreieren. Fenwick, der zuerst Stegreif-Entertainer war und die Theaterschule abbrach, wurde für seine „typografischen Comics" bekannt, die er unter dem Titel *Hall of Best Knowledge* für das Magazin *The Coast* schuf. Fantagraphics Books fasste 2008 sämtliche Folgen der Serie in Buchform zusammen. Neben Auftragsarbeiten für eine breite Palette von Kunden wie Nickelodeon, *The New York Times*, Pentagram, Random House und Urban Outfitters produziert Fenwick auch weiterhin typografische Comics für die *MOME*-Anthologie. 2009 gestaltete und illustrierte er ein *Hi* betiteltes Postkartenbuch für Chronicle Books. Fenwick wohnt und arbeitet in Halifax, Nova Scotia, in Kanada.

[FR] Originaire du Canada, Ray Fenwick est à la fois illustrateur, artiste lettreur et peintre. Il combine à merveille ces techniques pour créer des sacs, des tee-shirts, des prints, des comics etc. Après des débuts en improvisation, Fenwick abandonne ses études de théâtre et gagne en notoriété grâce à sa « bande dessinée typographique », *Hall of Best Knowledge*, réalisée pour le compte du magazine *The Coast*. En 2008, tous les épisodes de la série sont édités sous forme de livre chez Fantagraphics Books. À côté de ses travaux pour de prestigieux clients comme Nickelodeon, *The New York Times*, Pentagram, Random House et Urban Outfitters, Fenwick continue de créer des bandes dessinées typographiques pour l'anthologie *MOME*. In 2009, il a conçu et illustré une série de cartes rassemblées dans un étui intitulé *Hi* et publié chez Chronicle Books. Il vit et travaille à Halifax, dans la province de Nova Scotia, au Canada.

[ES] Ray Fenwick es un ilustrador, rotulador y pintor canadiense. Combinando todas estas habilidades, diseña bolsas, camisetas, pósters, cómics y muchos otros artículos. Tras intentar hacer fortuna con el género del teatro cómico improvisada y ser expulsado de una escuela de teatro, Fenwick alcanzó la fama con sus «cómics tipográficos» *Hall of Best Knowledge*, creados para la revista *The Coast*. En 2008, Fantagraphics Books recopiló todos los episodios de la serie en formato libro. Junto con su obra para una amplia cartera de clientes, entre quienes figuran Nickelodeon, *The New York Times*, Pentagram, Random House y Urban Outfitters, Fenwick continúa creando cómics tipográficos para la antología *MOME*. En 2009 diseñó e ilustró un libro de postales titulado *Hi* para Chronicle Books. Vive y trabaja en Halifax, Nueva Escocia (Canadá).

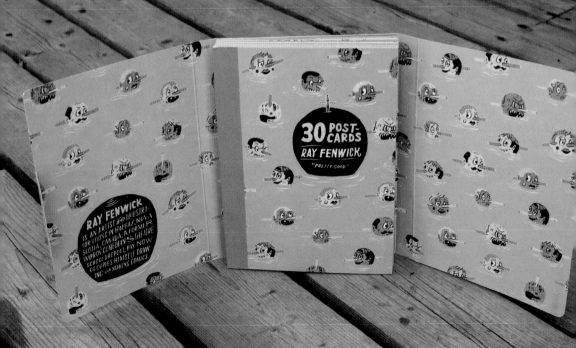

◄◄
Mind Your Fingers – postcard. Client: Subversive Cross Stitch.

◄
HI – postcard book. Published by Chronicle Books.

▲
Being Rich is Awesome – coin purse design. Client: Blue Q.

...SMALL PACKAGES

For those of us who have to give small gifts, the phrase "it's the thought that counts" is pretty much a mantra. Over and over we repeat this, desperate to believe that it's power will imbue the gift with magical size-defying properties. This year, however, will be different. The "small-gift wrap" below is not only something you "commissioned an artist to do"— wink wink— but it's also *covered* in flattery that will take the recipient's mind off of the size. They'll be so overwhelmed with compliments that the thought just might have a chance. Happy holidays!

Small Packages – gift wrap for the Canadian newsweekly *The Coast*.

Cover for a mini sketchbook. Client: If'N Books.

Kill. Personal work.

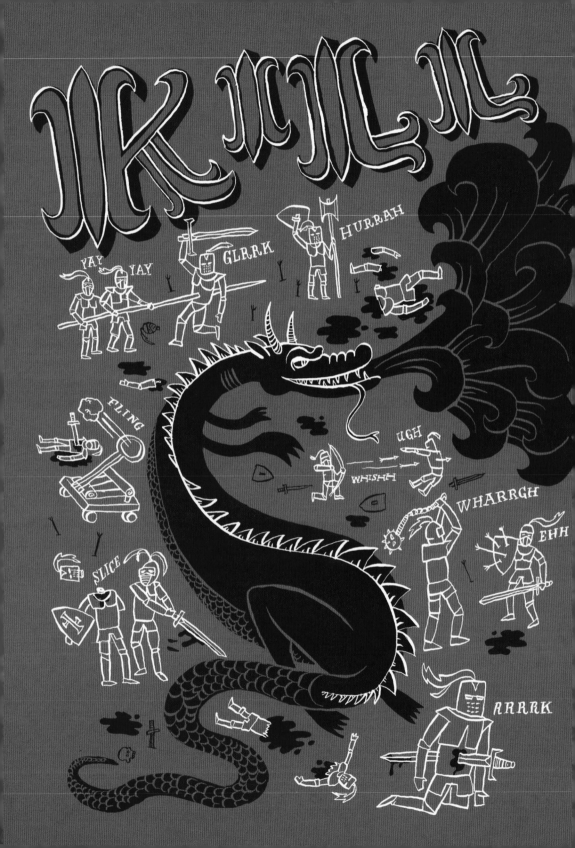

POKING POWER!
POWER of GENTLE CARESS! SQUEEZE POWER!
BUTTON PUSHING POWER!
POWER OF SHOULDER TAPPING!
Scratch POWER!

MAGICAL

POWER of DRUMMING fingers on desk!
POINTING AT THINGS POWER! CLAPPING POWER!
PUSH POWER! "OK" POWER! POWER of TICKLE!
PICKING THINGS UP POWER!
RUNNING FINGERS THROUGH HAIR POWER!

POWERS!

STROKE POWER!
PAT on HEAD POWER!
POWER of RUDE GESTURING!
MASSAGE POWER! POWER of FONDLE!
POWER OF SQUEEZING TOOTHPASTE!
fingernail BITING POWER!

◄◄
Magical Powers! – T-shirt design and poster. Client: Threadless.

◄
Yeti – pattern. Client: Gama-Go.

▲
Don't Freak Out – bag design. Client: Blue Q.

▲
K: Master of the Mystic Arts – two works that are part of a larger series. Personal work.

▶
Exceeds Expectations! Personal work.

Jochen Gerner

www.jochengerner.com
jochen.gerner@free.fr

[EN] Jochen Gerner studied at the Nancy National School of Fine Arts, France, where he received his degree in 1993. Since then he has been creating illustrations for books, magazines and newspapers (*Libération*, *Le Monde* and *The New York Times*, among others). Gerner has had many solo and group exhibitions, where he has shown his personal experimental graphic works. He has published several books, ranging from his travel diaries, *Courts-circuits géographiques*, to a collection of sketches made while having phone conversations, titled *Branchages*, both published by L'Association. In the beginning of 2009 the National Opera in Montpellier, France, staged an opera based on the graphic novel *Politique étrangère* which Gerner created together with Lewis Trondheim.

[DE] Jochen Gerner studierte an der École Nationale Supérieure des Beaux-Arts von Nancy, an der er 1993 seinen Abschluss machte. Seither realisiert er Illustrationen für Bücher, Zeitschriften und Zeitungen (darunter *Libération*, *Le Monde* and *The New York Times*). Seine persönlichen experimentellen Grafikarbeiten waren schon in vielen Einzel- und Gruppenausstellungen zu sehen. Gerner hat mehrere Bücher veröffentlicht – u. a. *Courts-circuits géographiques* betitelte Reisetagebücher und *Branchages*, gesammelte Kritzeleien, die im Verlauf von Telefongesprächen entstanden und beide bei L'Association erschienen. Anfang 2009 führte die Nationaloper im französischen Montpellier eine Oper auf, die auf der Graphic Novel *Politique étrangère* basiert, die Gerner zusammen mit Lewis Trondheim schuf.

[FR] Diplômé de l'École Nationale Supérieure des Beaux-Arts de Nancy (France) en 1993, Jochen Gerner réalise des illustrations pour l'édition et la presse (*Libération*, *Le Monde* et *The New York Times*, pour n'en citer que quelques-uns uns). Ses expérimentations graphiques ont fait l'objet de nombreuses expositions individuelles et collectives. Il a publié plusieurs ouvrages, de ses journaux de voyage, *Courts-circuits géographiques*, à *Branchages*, un recueil de croquis réalisés au cours de conversations téléphoniques et tous deux publiés par L'Association. Début 2009, l'Opéra National de Montpellier (France) met en scène un Opéra qui s'inspire du roman graphique *Politique étrangère* que Gerner a crée en collaboration avec Lewis Trondheim.

[ES] Jochen Gerner estudió en la Escuela de Bellas Artes de Nancy (Francia), donde se licenció en 1993. Desde entonces se ha dedicado a crear ilustraciones para libros, revistas y periódicos (*Libération*, *Le Monde* y *The New York Times*, entre otros). Gerner ha realizado multitud de exposiciones individuales y colectivas, donde ha mostrado sus obras gráficas experimentales más personales. Ha publicado además varios libros, que engloban desde sus diarios de viajes, *Courts-circuits géographiques*, hasta una recopilación de bocetos dibujados mientras mantiene conversaciones telefónicas titulada *Branchages*, ambos publicados por L'Association. A principios de 2009, la Ópera Nacional de Montpellier (Francia) estrenó una ópera basada en la novela gráfica *Politique étrangère*, que Gerner creó a cuatro manos con Lewis Trondheim.

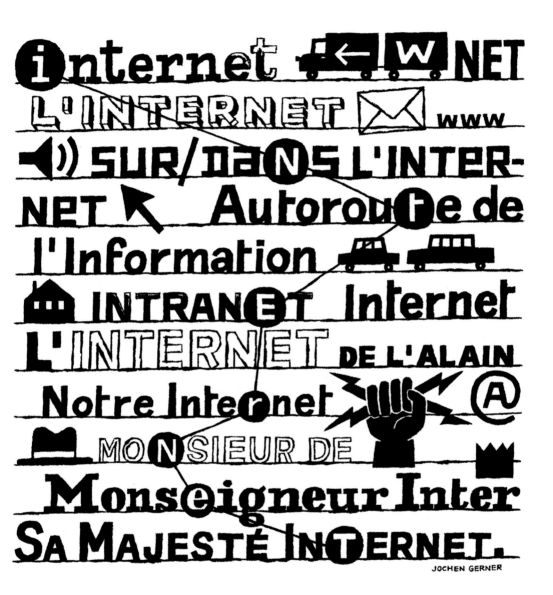

JOCHEN GERNER

◄◄
Gouache sur papier – illustration for a postcard (detail). Personal work.

◄
Cover for Tom McCarthy's book *Tintin and the Secret of Literature*. Client: Granta Books.

▲
Internet – illustration for the French newspaper *Libération*.

UN PETIT TAS DE GRAVIER ATTEND.

CHALONS-EN-CHAMPAGNE

TOUS UNIS POUR DES ÉCONOMIES AU QUOTIDIEN.

172 14

155

TL

DES TRONCS COUPÉS SE COUCHENT DANS LA PENTE.

CHAMPAGNE

LES CHAMPS S'ÉVAPORENT.

PIG

60 N

UNE RIVIÈRE LAITEUSE REFLÈTE UN CIEL MENTHE.

PEUGEOT

PARIS-NANCY 11/09/05

DANGER DE MORT

PARIS À 1 KM

TORCY

LA NUIT OFFRE DES REFLETS DANS LES VITRES.

NUIT + TUNNEL

NANCY- PARIS 05/10/05

BIDON CYLINDRIQUE BLEU

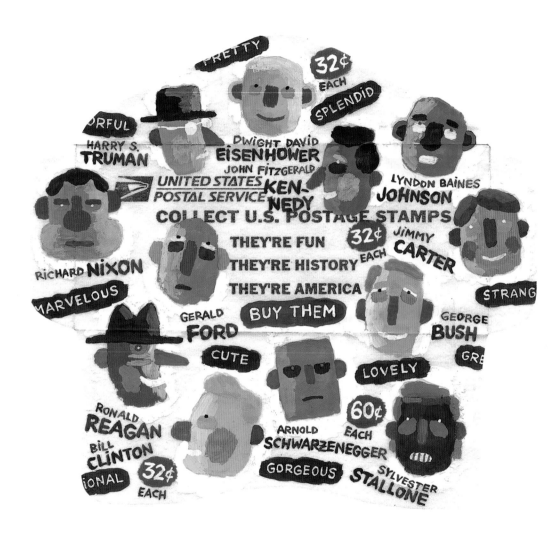

◀◀ Two pages from the accordion book *Grande Vitesse*, a collection of Gerner's railway drawings. © L'Association.

▲ *American Presidents* – gouache for the book *Prospectus Box*, collection Touzazimute. © Éditions du Rouergue.

▶ Cover and one card for the *Marseille, panorama polaire* project. Acrylic on postcards. Published by Éditions Fotokino.

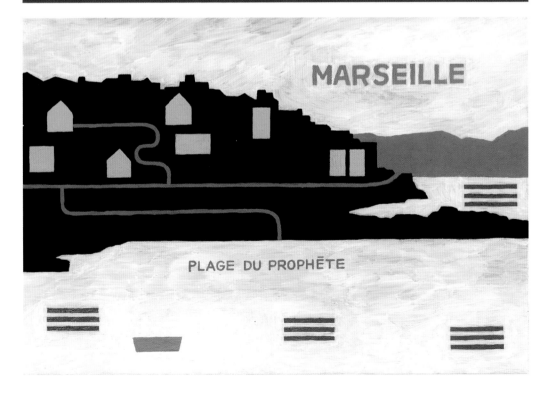

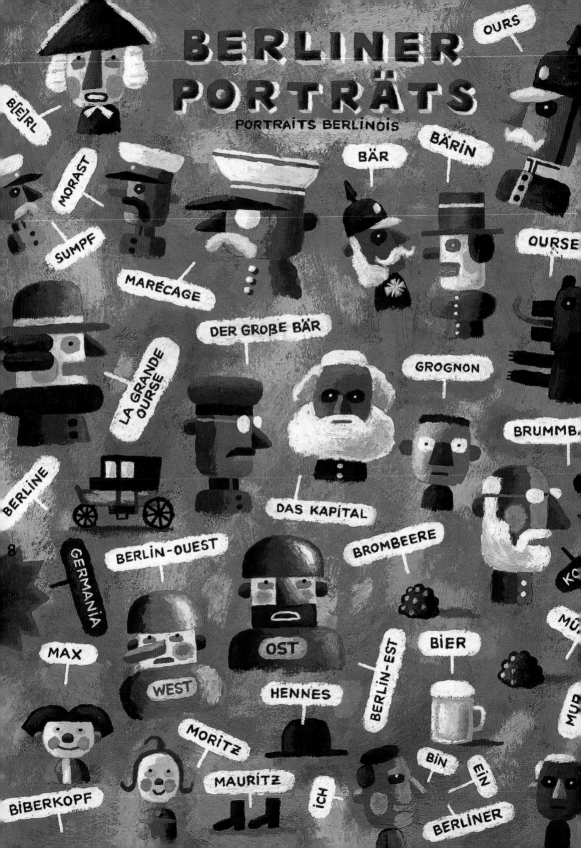

Map of Val Maubuée –
gouache on map
(detail), for the collec-
tive book Val Maubuée,
Itinéraires. © Trans
Photographic Press.

◀
Berlin Portraits –
gouache for the book
Berlin (Jochenplatz),
collection Touzazi-
mute. © Éditions du
Rouergue.

▶
Two illustrations for
the book Gagner sa
vie, est-ce la perdre?,
collection Chouette
penser! © Éditions
Gallimard.

Linzie Hunter

www.linziehunter.co.uk
linzie@linziehunter.co.uk

[EN] Linzie Hunter studied illustration at Chelsea College of Art and Design and currently lives in London. Born in Scotland and a graduate of Glasgow University, she first worked as a stage manager before venturing into illustration and lettering. She has since done work for Bloomsbury, *The Guardian*, Orange and Sainsbury's among others. In 2007 she started a series of lettering interpretations of spam subject lines she found in her in-box. After first being made available as prints, 30 of these typographic images were collected by Chronicle Books in the *Secret Weapon* postcard book. Thanks to the international attention this project received, Hunter has been asked to use her lettering skills for anything from tea towels and postcards to editorial illustrations and international advertising campaigns.

[DE] Linzie Hunter studierte Illustration am Chelsea College of Art and Design und lebt in London. Die gebürtige Schottin und Absolventin der Universität Glasgow arbeitete vor ihrem Wechsel zur Illustration und zum Schriftdesign als Bühneninspizientin. Seither hat sie unter anderem für Bloomsbury, *The Guardian*, Orange und Sainsbury's gearbeitet. 2007 begann sie eine Serie mit typografischen Interpretationen von Spam-Betreffzeilen aus ihrer Inbox. Nachdem sie zuerst im Druck erschienen waren, brachte Chronicle Books 30 dieser typografischen Bilder in dem Postkartenbuch *Secret Weapon* heraus. Das Projekt erregte international Aufmerksamkeit, so dass Hunter seither Anfragen nach Typografiedesigns für alle möglichen Artikel vom Geschirrtuch über Postkarten bis hin zu Zeitungs- und Zeitschriftenillustrationen oder internationalen Werbekampagnen erhält.

[FR] Linzie Hunter a étudié l'illustration au Chelsea College of Art and Design et vit désormais à Londres. Née en Écosse et diplômée de l'Université de Glasgow, elle débute sa carrière comme régisseuse avant de s'aventurer dans l'illustration et le lettrage. Elle a depuis lors travaillé pour de grands noms comme Bloomsbury, *The Guardian*, Orange et Sainsbury's. En 2007, elle se lance dans la typo de textes de spam reçus dans sa boîte mail. Disponibles dans un premier temps sous forme de prints, 30 de ces images typographiques ont été rassemblées sous forme de cartes dans un étui intitulé *Secret Weapon* et publié chez Chronicle Books. Grâce à l'engouement international suscité par ce projet, Hunter a été sollicitée pour mettre à profit ses compétences typographiques pour toute une gamme de produits, de torchons aux cartes postales en passant par des illustrations éditoriales et des campagnes de pub internationales.

[ES] Linzie Hunter estudió ilustración en el Chelsea College of Art and Design y actualmente reside en Londres. Nacida en Escocia y graduada por la Universidad de Glasgow, trabajó inicialmente como escenógrafa antes de aventurarse en el mundo de la ilustración y la rotulación. Desde entonces ha colaborado con Bloomsbury, *The Guardian*, Orange y Sainsbury's, entre otros clientes. En 2007 empezó a rotular las líneas de asunto de los mensajes de correo basura que llegaban a su buzón. Tras publicarlas en un principio a modo de carteles, Chronicle Books recopiló 30 de estas imágenes tipográficas en el libro de postales *Secret Weapon*. Gracias a la atención internacional que ha recibido este proyecto, Hunter ha visto como sus habilidades para la rotulación cobraban vida en todo tipo de artículos, desde servilletas y postales hasta ilustraciones editoriales y campañas publicitarias.

◄◄
Sometimes You Just Know – limited edition silk-screen print. Client: Art Bureau.

◄
Design for silk-screen printed kitchen towels. Client: Patapri.com.

▲
Proyecto Pollo – logo. Personal work.

Cover for Sue Limb's book *Girls to Total Goddesses*. Art director: Kate Clarke. Client: Bloomsbury.

Coney. Personal work.

27 Businesses to Run in a Recession – double page illustration (detail) for the UK-based magazine *Real Business*.

Say "GOODBYE" to Love FAILURES and LONELINESS

◄◄
How to Invest in 2009 – illustration for the magazine *Canadian Business*.

◄
Say Goodbye to Love Failures and Loneliness – from the postcard book *Secret Weapon*. Published by Chronicle Books.

▲
Enter the World of Boundless Sensual Enjoyments – from the postcard book *Secret Weapon*. Published by Chronicle Books.

Cover for Elen Caldecott's book *How Kirsty Jenkins Stole the Elephant*. Art director: Kate Clarke. Client: Bloomsbury.

Supermarket – illustration (detail) for the Costa Rican magazine *Revista Colectiva*.

SUPER
Market

E✕PRESS

Hous
C

DEAL OF
THE DAY

£

$

FROZEN

FRESH

Sale

PRICE CHECKED

24/7

NEW

Managers Special

VALUE

FREE

3 for

Jan Kallwejt

www.kallwejt.com
jan@kallwejt.com

[EN] Jan Kallwejt is a freelance illustrator and graphic designer born in Warsaw, Poland. He first worked as a designer and art director for the Warsaw-based HYPERmedia interactive agency, after which he moved to Hamburg, Germany, to join the Fork Unstable Media agency. After leaving Hamburg he returned to Warsaw, where he established his own studio focusing on illustration, clothing design and personal projects. He works for clients in Europe and North America, including Nike, Reebok, *The Guardian*, *Wired* and the Polish editions of *Playboy* and *Newsweek*. Kallwejt's work has been featured in many magazines and books. It can also be found in the different group exhibitions in which he regularly participates. He currently divides his time between Warsaw and Malaga, Spain.

[DE] Jan Kallwejt, in Warschau geboren, ist Freelance-Illustrator und -Grafikdesigner. Er arbeitete zuerst als Designer und Art-Director für die Warschauer Agentur HYPERmedia interactive communication und zog dann nach Hamburg, wo er bei der Agentur Fork Unstable Media begann. Nach seiner Rückkehr aus Hamburg gründete er in Warschau ein eigenes Studio mit Schwerpunkt auf Illustration, Textildesign und persönlichen Projekten. Er arbeitet für Kunden in Europa und Nordamerika, u. a. Nike, Reebok, *The Guardian*, *Wired* und die polnischen Ausgaben von *Playboy* und *Newsweek*. Kallwejts Arbeiten sind in zahlreichen Büchern und Zeitschriften erschienen und werden immer wieder in Gruppenausstellungen gezeigt. Zurzeit lebt er in Warschau und in Málaga.

[FR] Illustrateur et graphiste free-lance, Jan Kallwejt est né à Varsovie, en Pologne. Il travaille dans un premier temps comme designer et directeur artistique pour l'agence interactive de Varsovie HYPERmedia pour ensuite s'installer à Hambourg, en Allemagne, où il rejoint l'agence Fork Unstable Media. Il quitte ensuite Hambourg pour revenir à Varsovie où il crée son propre studio et se concentre sur l'illustration, le design vestimentaire et ses projets personnels. Il travaille pour l'Europe et les États-Unis et compte parmi ses clients des sociétés comme Nike, Reebok, *The Guardian*, *Wired* et les éditions polonaises de *Playboy* et de *Newsweek*. Les travaux de Kallwejt figurent dans de nombreux livres et magazines. Ses œuvres sont également exposées dans les diverses expositions collectives auxquelles il participe régulièrement. Il partage désormais son temps entre Varsovie et Malaga, en Espagne.

[ES] Jan Kallwejt es un ilustrador y diseñador gráfico freelance nacido en Varsovia (Polonia). Tras iniciar su andadura como diseñador y director de arte en la agencia interactiva con sede en Varsovia HYPERmedia, se trasladó a Hamburgo (Alemania) para trabajar en la agencia Fork Unstable Media. Regresó posteriormente a Varsovia, donde fundó su propio estudio, centrado en la ilustración, el diseño de moda y sus proyectos personales. Trabaja para clientes de Europa y Norteamérica, entre los que se cuentan Nike, Reebok, *The Guardian*, *Wired* y las ediciones polacas de *Playboy* y *Newsweek*. El trabajo de Kallwejt ha aparecido en multitud de revistas y libros. También puede encontrarse en diversas exposiciones colectivas, en las que participa con regularidad. Actualmente reparte su tiempo entre Varsovia y Málaga (España).

Wise Monkeys − T-shirt design. Client: Chrum.com.

Got to Have Balls − T-shirt design. Client: Chrum.com.

Sleeve for the vinyl single *Datarock − Give it Up*. Client: Nettwerk.

▲
Eco Family – illustration for the Polish
magazine *Przekrój*.

▶
Finanzamt – illustration for the Polish
magazine *Neon*.

▶▶
Radio for Abroad – billboard. Agency:
Menska. Client: Polskie radio.

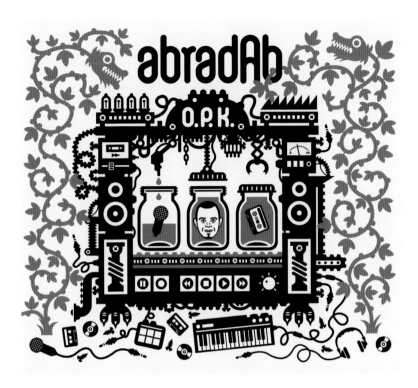

◄

Coal miner – book
illustration. Client:
Będzin Beat.

►

Cover for the CD
Abradab O.P.K.
Designed with: Kobas
Laksa. Client: Abradab.

Research to Order – illustration for the
Polish magazine *Przekrój*.

Industrial Nature – T-shirt design.
Client: Threadless.

Max Kisman

www.maxkisman.com

[EN] Max Kisman was born in Doetinchem, the Netherlands. Since graduating in 1976 from the Gerrit Rietveld Academy in Amsterdam, he has been active as a graphic designer, illustrator, type designer, motion graphics designer and teacher. In the eighties he started out designing the magazines *Vinyl Music* and *Language Technology* (forerunner of the US-based magazine *Wired*). Kisman's numerous typefaces are published through the FontFont label and his own Holland Fonts foundry. His iconic television graphics for VPRO TV, a Dutch public broadcasting network, landed him a job as art director at Wired TV and Hot Wired in San Francisco in 1996. Since returning to the Netherlands in 2005, he has been working as a freelance graphic designer and illustrator for a wide range of clients.

[DE] Max Kisman ist im niederländischen Doetinchem geboren; nachdem er 1976 sein Studium an der Amsterdamer Gerrit Rietveld Academie abschloss, arbeitete er als Grafikdesigner, Illustrator, Schriftdesigner, Film- und TV-Animationsdesigner und Lehrender. In den 80er-Jahren gestaltete er die Zeitschriften *Vinyl Music* und *Language Technology* (ein Vorläufer des US-amerikanischen Magazins *Wired*). Kisman hat viele Schriften entworfen, die in der FontFont-Library und seiner eigenen Holland Fonts-Foundry erscheinen. Durch seine TV-Icons für den niederländischen öffentlich-rechtlichen Sender VPRO TV erhielt er 1996 einen Job als Art-Director bei Wired TV und Hot Wired in San Francisco. Seit er 2005 in die Niederlande zurückkehrte, arbeitet er als Freelance-Grafikdesigner und -Illustrator für eine breite Palette von Kunden.

[FR] Max Kisman est né à Doetinchem, aux Pays-Bas. Depuis l'obtention de son diplôme à la Gerrit Rietveld Academy d'Amsterdam en 1976, il a travaillé tour à tour comme graphiste, illustrateur, typographe, designer Motion Graphic et professeur. Dans les années quatre-vingts, il se lance dans la conception des magazines *Vinyl Music* et *Language Technology* (précurseur du magazine américain *Wired*). Les polices de caractère de Kisman sont publiées sous le label FontFont et par la fonderie Holland Fonts dont il est le fondateur. Son graphisme iconoclaste pour la chaîne de télévision publique néerlandaise VPRO, lui a permis de décrocher en 1996 un poste de directeur artistique à Wired TV et Hot Wired (San Francisco). Depuis son retour aux Pays-Bas en 2005, il travaille comme illustrateur et graphiste free-lance pour une clientèle variée.

[ES] Max Kisman nació en Doetinchem (Países Bajos). Tras graduarse en 1976 en la Academia Gerrit Rietveld de Ámsterdam, ha trabajado como diseñador gráfico, ilustrador, tipógrafo, diseñador de motion graphics (gráficos animados) y profesor. En la década de 1980 empezó a diseñar las revistas *Vinyl Music* y *Language Technology* (precursora de la estadounidense *Wired*). Las numerosas tipografías de Kisman se publican con la fundición FontFont y con su propia fundición, Holland Fonts. Sus icónicos gráficos para la televisión VPRO TV, una cadena de radiodifusión pública holandesa, le valieron el puesto de director de arte en Wired TV y Hot Wired en San Francisco en 1996. Tras su regreso a los Países Bajos en 2005, ha trabajado como ilustrador y diseñador gráfico freelance para un amplio abanico de clientes.

◀◀
Series of six postage stamps on the theme of children. Client: TNT Post.

◀
Poster for the 100th anniversary of the death of Toulouse-Lautrec. Client: Le Salon Nouveau des Cent.

▲
Illustration for the second *Building Letters* magazine about India.

The proBLeM wIth coMPutErs iS thAt theRe IS nOT eNouGh AfrICA iN THeM

BOdY

WHaT's PIsSing ME oFf iS thAt THEY usE so liTtlE oF mY

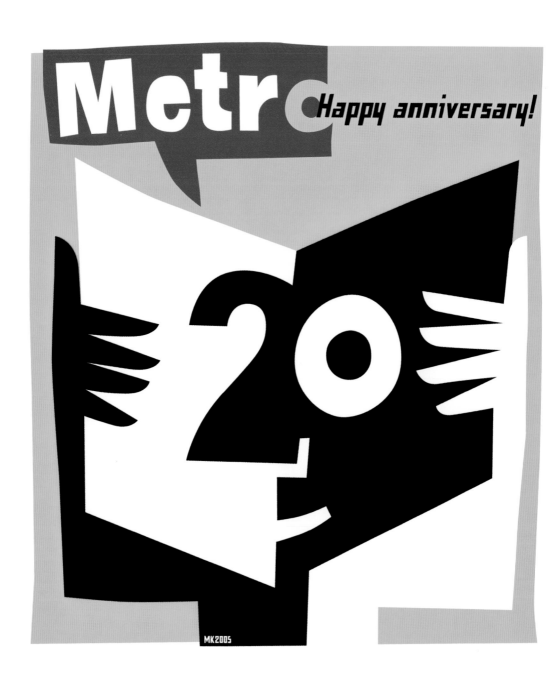

MK2005

◄◄ Two introductory spreads with quotes by Brian Eno for the US-based magazine *Wired*.

▲ Cover for the 20th anniversary issue of the US-based weekly magazine *Metro*.

▶ Poster for the exhibition of 90 posters by 90-year-old Dutch graphic designer Jan Bons. Client: de Kunsthal.

JanBons90
affiches. 90
8 maart t/m 12 mei 2008
Kunsthal
Rotterdam

MK2008

Max Kisman's

LIEVE
LUST

Beurs van Kleine Uitgevers
Paradiso Amsterdam
11 december 2005

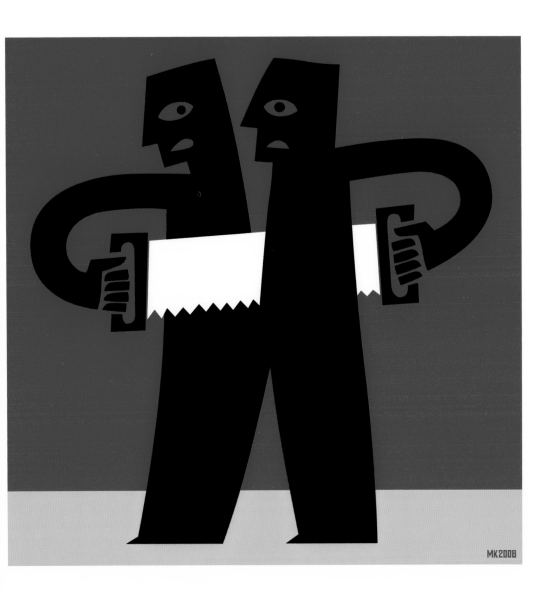

◄
Promotional poster for the publication
of the book *Lieve Lust*. Published by
Max Kisman Studio.

▲
Illustration for the Dutch newspaper
De Volkskrant for an essay on separatist
tendencies in Belgium.

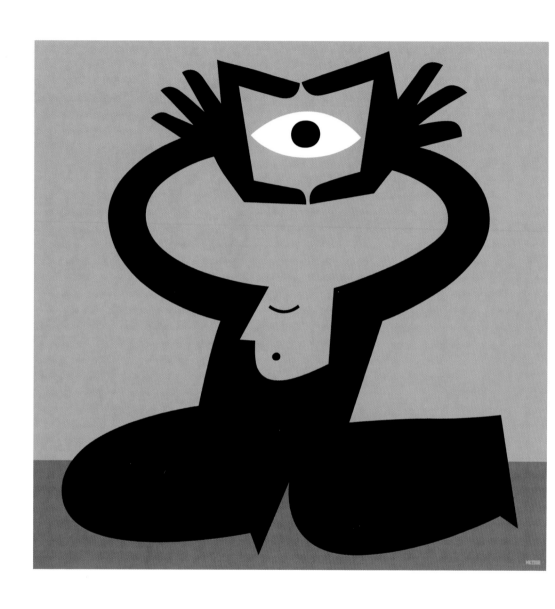

Illustration to accompany a poem by
Adriaan Jaeggi. Client: Wereldboek.

Illustration for the Dutch newspaper
Het Financieël Dagblad for an essay on
globalisation policies.

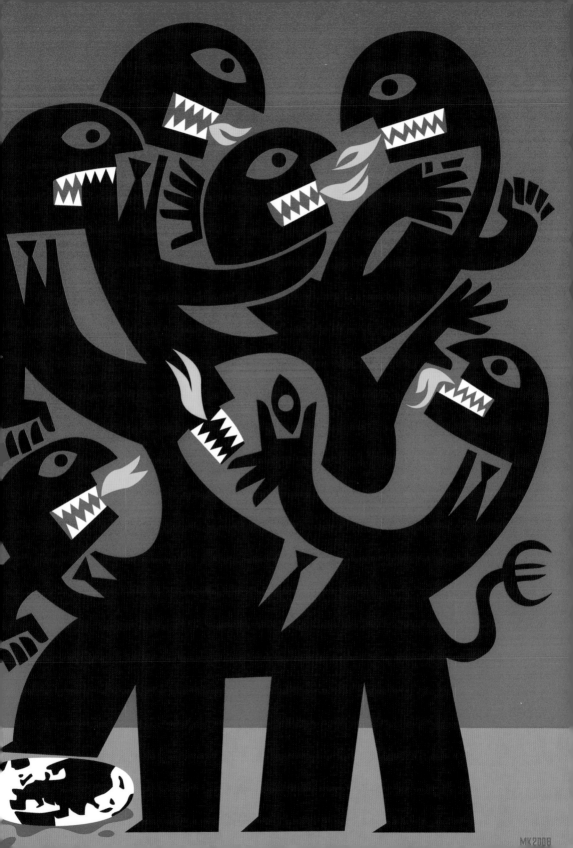

Stuart Kolakovic

www.stuartkolakovic.co.uk
stu@stuartkolakovic.co.uk

[EN] Stuart Kolakovic is an illustrator based in the Midlands, England. He graduated from Kingston University in 2007. His artwork is heavily inspired by his family's Eastern European heritage. *Milorad*, an 80-page comic book about his Serbian grandfather, won a 2007 D&AD Best of New Blood award. Immediately after that, he took the second prize in the Observer/Jonathan Cape Graphic Short Story Competition. Kolakovic is currently working on a full-length comic book entitled *Lichen*, which will be published by Blank Slate Books in 2010. He is represented by Heart artists' agency and some of his selected clients include Sony, Barclays Bank, John Murray Publishers, *The Guardian* and *The Sunday Telegraph*. His personal work has been shown in several group exhibitions.

[DE] Stuart Kolakovic ist Illustrator, lebt in den englischen Midlands und schloss sein Studium an der Kingston University 2007 ab. Sein künstlerischer Output ist deutlich vom osteuropäischen Familienbackground geprägt. *Milorad*, ein 80-seitiger Comic-Band über seinen serbischen Großvater, wurde 2007 mit dem D&AD Best of New Blood Award ausgezeichnet. Kurz darauf erhielt Kolakovic den zweiten Preis im The Observer/Jonathan Cape Graphic Short Story-Wettbewerb. Derzeit arbeitet Kolakovic an einem längeren, *Lichen* betitelten Comicbuch, das 2010 bei Blank Slate Books erscheint. Vertreten von der Künstleragentur Heart, arbeitet er für ausgewählte Kunden wie Sony, Barclays Bank, John Murray Publishers, *The Guardian* and *The Sunday Telegraph*. Seine persönlichen Arbeiten waren schon in mehreren Gruppenausstellungen zu sehen.

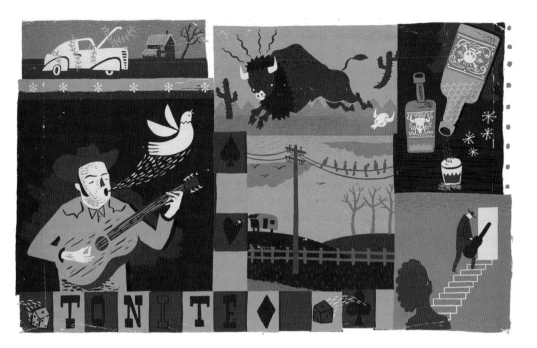

[FR] Illustrateur diplômé de l'Université de Kingston en 2007, Stuart Kolakovic est basé dans les Midlands, en Angleterre. Son travail s'inspire fortement de l'héritage culturel d'Europe de l'Est légué par sa famille. Il remporte en 2007 le D&AD Best of New Blood Award pour *Milorad*, un livre de bandes dessinées de 80 pages qui met en scène son grand-père serbe. Il enchaîne avec le deuxième prix du concours Observer/Jonathan Cape Graphic Short Story Competition. Kolakovic travaille actuellement sur *Lichen*, un livre de bandes dessinées publié chez Blank Slate Books et dont la sortie est prévue pour 2010. Il est représenté par l'agence Heart et compte parmi ses clients des noms privilégiés comme Sony, la banque Barclays, la maison d'édition John Murray Publishers, *The Guardian* et *The Sunday Telegraph*. Ses travaux ont été présentés au sein de nombreuses expositions collectives.

[ES] Stuart Kolakovic es un ilustrador afincado en los Midlands (Inglaterra). Se licenció en la Universidad de Kingston en 2007. Su obra artística se inspira profundamente en su legado familiar de la Europa del Este. *Milorad*, un cómic de 80 páginas acerca de su abuelo serbio, ganó el premio D&AD Best of New Blood en 2007. Inmediatamente después, Kolakovic quedó segundo en el concurso de novela corta gráfica convocado por Observer/Jonathan Cape. En la actualidad, Kolakovic trabaja en un cómic en formato libro titulado *Lichen*, que publicará Blank Slate Books en 2010. Su representación corre a cargo de la agencia Heart y entre sus selectos clientes figuran Sony, Barclays Bank, John Murray Publishers, *The Guardian* y *The Sunday Telegraph*. Su trabajo personal ha formado parte de varias exposiciones colectivas.

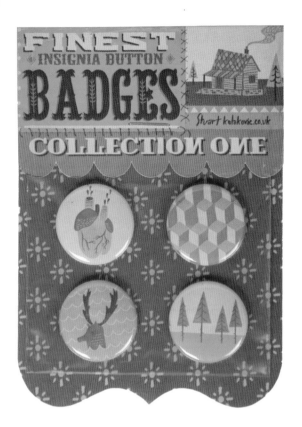

FINEST
◆ INSIGNIA BUTTON ◆
BADGES
Stuart.kolakovic.co.uk
COLLECTION ONE

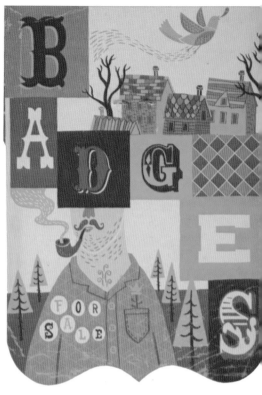

BADGES
FOR SALE

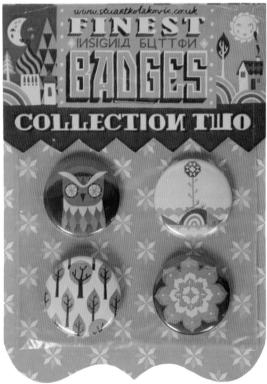

www.stuartkolakovic.co.uk
FINEST
INSIGNIA БЦТТFИ
BADGES
COLLECTION TWO

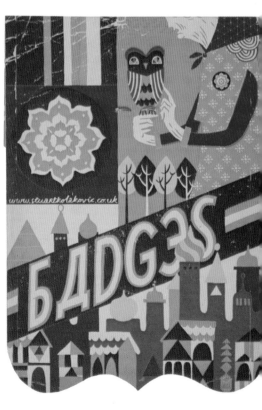

www.stuartkolakovic.co.uk
БADGЭS

◄◄
Alternative Country Music – illustration for the UK-based music magazine *Plan B*.

◄
Finest Insignia Button Badges. Collection One and Two. Self promotion.

▲
Cover for William Blacker's book *Along the Enchanted Way*. Client: John Murray Publishers.

▲
The Big Push – press ad and DVD cover. Clients: *Document Skateboard Magazine* and Sony.

►
Love Addicts – illustration for the Hong Kong-based magazine *The One & Only*.

Stuart kolakovic.co.uk

ЖИВОТ

◄

The Joyful Bewilderment – limited edition silk-screen print for *The Joyful Bewilderment* exhibition at Rough Trade in London, UK.

►

Cover for the CD *No Man's Land*, by the Autonomads. Client: Pumpkin Records.

►►

Old School Slalom Skateboard – limited edition skateboard for the exhibition *Screen if you wanna go faster!!!*, a show curated and printed by Error Solutions in London, UK.

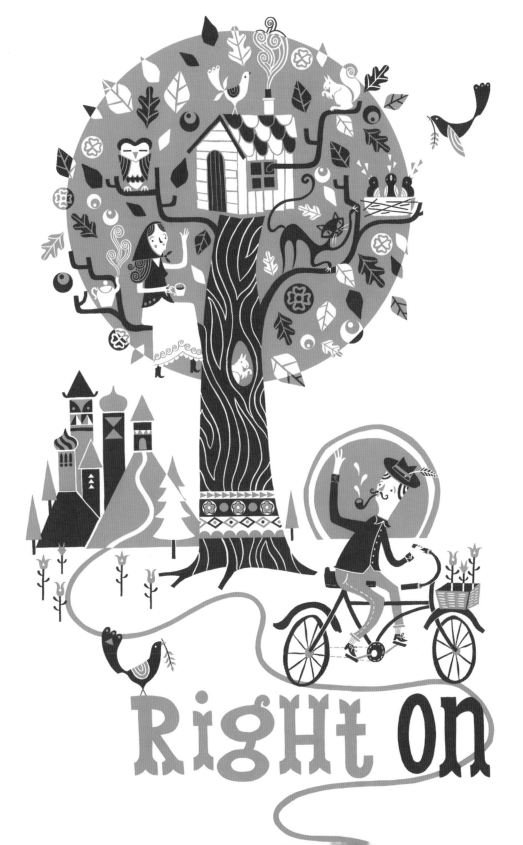

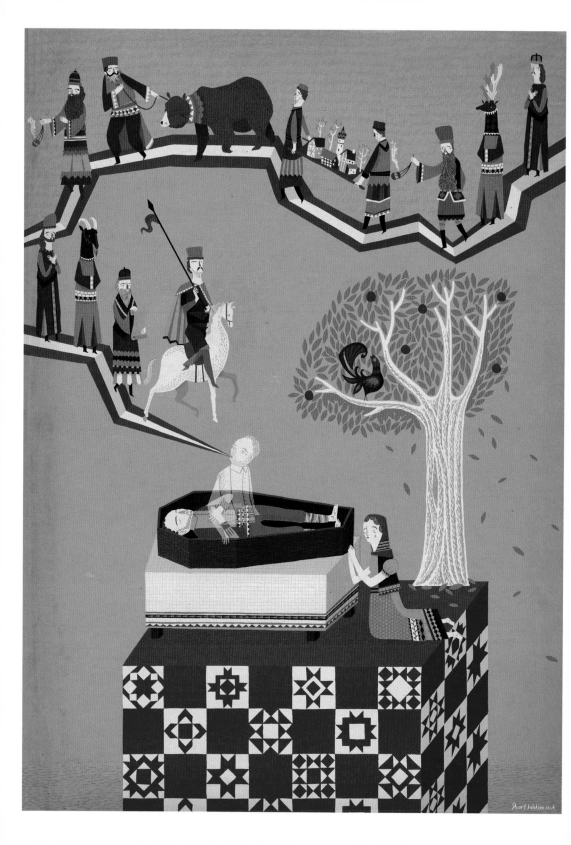

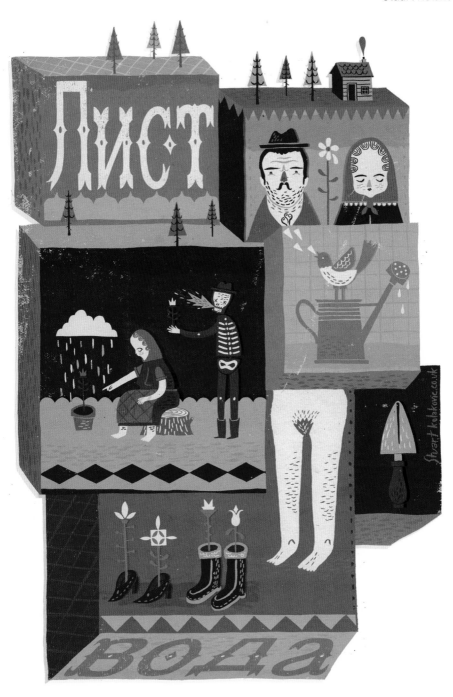

Right On – design for silk-screen printed kitchen towels. Client: ToDryFor.com.

Russia – limited edition giclée print for the *Russians* exhibition at Rotopol Press in Kassel, Germany.

The Florist's Wife. Client: Sing Statistics.

Kuanth

www.kuanth.com
kuanth76@yahoo.com

[EN] Kuanth is a graphic designer and illustrator from Singapore. He worked as a senior graphic designer in the publishing and advertising industry until 2002, when he made the change to become a freelance artist. Kuanth's work has been included in several exhibitions organised by Tiger Translate (an initiative showcasing emerging Asian artists), as well as other art shows in Singapore and abroad. In 2009 he, together with a couple of friends, opened a restaurant and hair salon called Hairloom & Caramel, for which he also designed the visual identity. Alongside his commercial assignments for clients like Nokia, Motorola, Levi Strauss, Nike, Coca-Cola, Heineken, HP and Sony Ericsson, he spends his time creating personal works like toys and dolls, as well as acrylic sculptures.

[DE] Kuanth ist ein Grafikdesigner und Illustrator aus Singapur. Bis 2002 arbeitete er als leitender Grafikdesigner in der Verlags- und Werbebranche und seither als Freelancer. Kuanths Arbeiten sind in mehreren Ausstellungen von Tiger Translate – einer Initiative, die junge asiatische Künstler präsentiert –, und anderen Schauen in Singapur und im Ausland gezeigt worden. 2009 eröffnete er mit Freunden unter dem Namen Hairloom & Caramel eine Kombination von Restaurant und Friseursalon, deren visuelle Identität er gestaltete. Neben kommerziellen Aufträgen für Kunden wie Nokia, Motorola, Levi Strauss, Nike, Coca-Cola, Heineken, HP und Sony Ericsson arbeitet er auch an persönlichen Projekten wie Spielzeugen, Puppen und Acrylskulpturen.

[FR] Originaire de Singapour, le graphiste et illustrateur Kuanth a travaillé dans le secteur de l'édition et de la pub en tant que graphiste senior jusqu'en 2002, date à laquelle il décide de devenir indépendant. Ses travaux ont fait l'objet de nombreuses expositions organisées par Tiger Translate (une initiative visant à promouvoir les artistes asiatiques émergents) ainsi que d'autres expositions artistiques à Singapour et à l'étranger.
En 2009, il ouvre avec un couple d'amis Hairloom & Caramel un restaurant -salon de coiffure dont il a signé l'identité visuelle. Parallèlement aux travaux qu'il exécute pour des clients comme Nokia, Motorola, Levi Strauss, Nike, Coca-Cola, Heineken, HP et Sony Ericsson, Kuanth consacre son temps à la création d'objets personnels (jouets, poupées) et de sculptures acryliques.

[ES] Kuanth es un diseñador gráfico e ilustrador de Singapur. Trabajó como diseñador gráfico sénior en el sector editorial y publicitario hasta 2002, año en que decidió convertirse en artista freelance. La obra de Kuanth se ha incluido en varias exposiciones organizadas por Tiger Translate (una iniciativa que pretende dar a conocer a los artistas asiáticos emergentes), además de en otras muestras artísticas tanto en Singapur como en el extranjero. En 2009, junto con un par de amigos, Kuanth abrió un restaurante-peluquería llamado Hairloom & Caramel, para el cual diseñó la identidad visual. Además de trabajar en los encargos comerciales para clientes como Nokia, Motorola, Levi Strauss, Nike, Coca-Cola, Heineken, HP y Sony Ericsson, Kuanth dedica parte de su tiempo a crear obras personales como juguetes, muñecas y esculturas con acrílicos.

◀◀
Two works from the *Freak Show* series.
Personal work.

▲
Corporate identity for Hairloom (salon)
and Caramel (café).
www.hairloomandcaramel.blogspot.com

▶
One work from the *Dark* series. Personal
work.

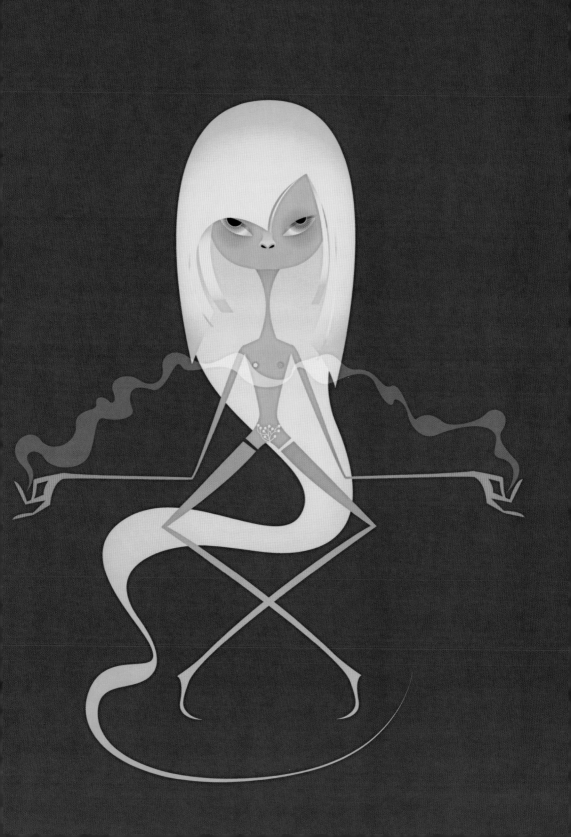

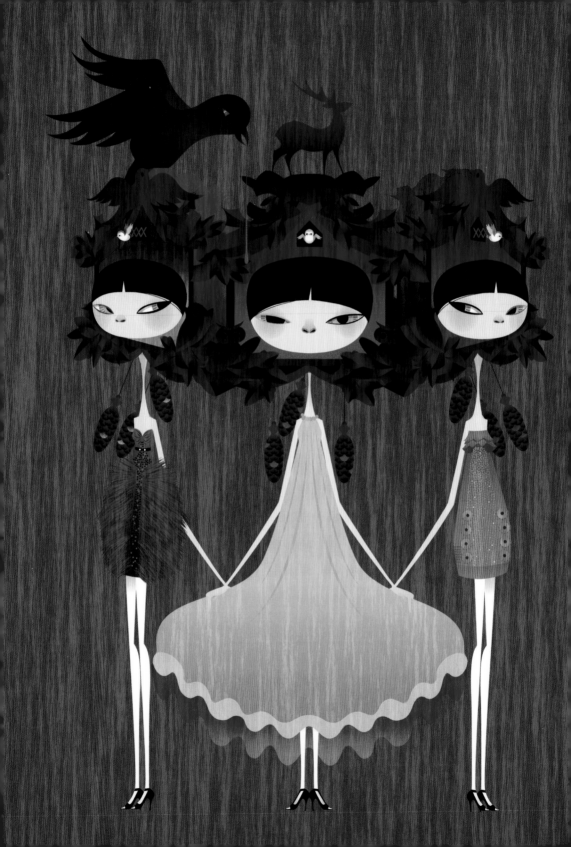

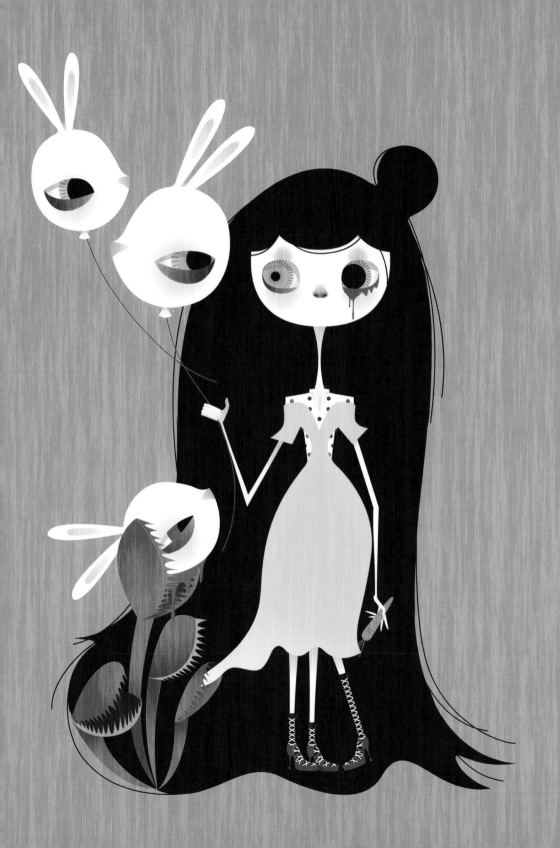

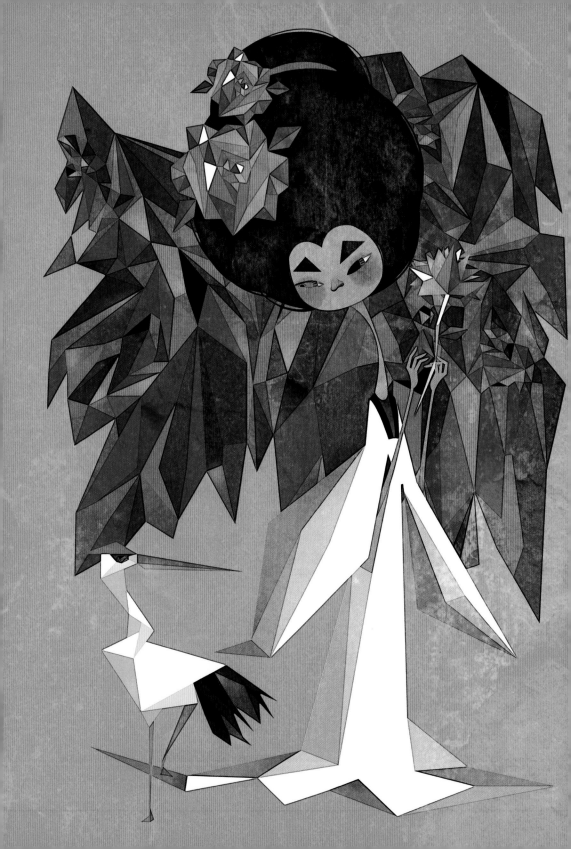

◄◄
Two works from the *Drawing Blood* series. Client: *Hint Fashion Magazine*.

◄
Work created for the group exhibition *Hypercolour*.

▲
Card designs and illustration (see page 155). Corporate identity for Crumbs Bake Shoppe.

Sebastian Kubica

www.sebastiankubica.of.pl
sebakubica@gmail.com

[EN] Sebastian Kubica was born in Żywiec, Poland. He studied graphic design under Professor R. Kalarus and graphic arts under Professor R. Starak at the Katowice section of the Cracow Academy of Fine Arts. He is one of a small number of graphic designers in Poland who carry on the famed tradition of Polish poster design. Although many graphic designers create a poster from time to time, Kubica has dedicated most of his professional career to working in this particular area. His work has been exhibited in Poland, Japan, USA, Germany, China, France and many other countries around the world. He is currently teaching at the Art Faculty in Cieszyn of the Silesian University in Katowice. Kubica has received many awards for his poster designs and has been honoured in Poland and abroad.

[DE] Sebastian Kubica, geboren in Żywiec, Polen, studierte Grafikdesign bei Prof. R. Kalarus und freie Grafik bei Prof. R. Starak an der Kattowitzer Abteilung der Krakauer Kunsthochschule. Er gehört zu den wenigen polnischen Grafikdesignern, die Polens berühmte Plakatdesign-Tradition hochhalten. Während viele Grafikdesigner dann und wann einmal ein Poster entwerfen, hat Kubica den größten Teil seiner Karriere in diesem speziellen Bereich gearbeitet. Seine Arbeiten sind in aller Welt, u. a. in Polen, Japan, den USA, Deutschland und China, ausgestellt worden. Derzeit doziert er an der Teschener Kunstfakultät der Schlesischen Universität von Kattowitz. Kubica hat für seine Plakatentwürfe inner- und außerhalb Polens zahlreiche Preise und Auszeichnungen erhalten.

[FR] Sebastian Kubica est né à Żywiec, en Pologne. Il a étudié le design graphique dans la section d'art graphique de Katowice de l'Académie des Beaux-Arts de Cracovie sous la houlette du professeur R. Kalarus et les arts graphiques sous celle du professeur R. Starak. Il fait partie de cette petite minorité de graphistes polonais qui maintiennent la célèbre tradition du design d'affiche polonais. Si de nombreux graphistes réalisent de temps à autre des affiches, Kubica leur consacre la plus grande partie de sa carrière professionnelle. Ses travaux ont été exposés en Pologne, au Japon, aux US, en Allemagne, en Chine, en France et dans de nombreux autres pays à travers le monde. Il enseigne actuellement à la Faculté d'Art de Cieszyn qui est rattachée l'Université de Silésie de Katowice. Kubica a été récompensé à maintes reprises pour son design d'affiche aussi bien dans sa Pologne natale qu'à l'étranger.

[ES] Sebastian Kubica nació en Żywiec (Polonia). Estudió diseño gráfico bajo la tutela del profesor R. Kalarus y artes gráficas bajo la del profesor R. Starak en la sección de Katowice de la Academia de Bellas Artes de Cracovia. Es uno de los pocos diseñadores gráficos en Polonia que dan continuidad a la famosa tradición del diseño de carteles polaco. A diferencia de la mayoría de diseñadores gráficos, que crean un póster de vez en cuando, Kubica ha consagrado la mayor parte de su carrera profesional a este campo concreto. Su obra se ha expuesto en Polonia, Japón, Estados Unidos, Alemania, China, Francia y muchos otros países. Actualmente es profesor en la Facultad de Arte de Cieszyn, integrada en la Universidad Silesiana de Katowice. Kubica ha recibido multitud de premios por sus diseños de carteles, tanto en su tierra natal como en el extranjero.

TORSTRASSE 66
10119 BERLIN
WWW.PIGASUS-GALLERY.DE
WWW.POLNISCHEVERSAGER.DE

POLNISCHE VERLAG
VERSAGER
WYDAWNICTWO POLSKICH NIEUDACZNIKÓW

◄◄
Poster for an exhibition of Polish posters.
Client: Dydo Poster Collection.

◄
Publishing House of Polish Losers –
poster. Client: Pigasus Gallery.

▲
Opera on Paper – poster. Client:
Krzysztof Marcinkiewicz Poster Gallery.

▲
100th Anniversary of the Drewnica Hospital for the Neurotic and Mentally Ill — poster. Client: Sylwester Marzoch.

▶
Poster for an exhibition of Polish theatre posters. Client: Dydo Poster Collection.

JAZZ POSTERS POLISH SCHOOL OF POSTERS
1950s–1980s

JAZZ AT LINCOLN CENTER
BROADWAY at 60th, NEW YORK, NY
OCTOBER 30 – NOVEMBER 27, 2006

CONTEMPORARY POSTERS, NEW YORK, NY
www.contemporaryposters.com

S. Kushin 2006

*Jazz Posters, Polish School of Posters
1950s-1980s* – poster. Client: Dydo
Poster Collection.

We are Very Pleased With This Work –
poster. Client: Art Faculty in Cieszyn of
the Silesian University in Katowice.

Poster for a solo exhibition. Client:
Dydo Poster Collection.

Poster for Club Morfeusz.

PLAC
K.MIARKI
6
KATOWICE

CLUB
MORFEUSZ

S. Kubica

Lab Partners

www.lp-sf.com
info@lp-sf.com

[EN] The design and illustration duo Lab Partners consists of Sarah Labieniec and Ryan Meis. Labieniec first attended the Rhode Island School of Design (RISD) and then transferred to Ringling College of Art and Design, where she received her Batchelor of Fine Arts degree in illustration. At Ringling she met graphic design student Ryan Meis and, after graduation in 2008, the couple moved to San Francisco. The duo has been responsible for a steady output of illustrations and prints, characterised by a style reminiscent of mid-20th century American illustration. Their letterpress and Gocco prints have created a steady fan base thanks to their Etsy shop. In 2009 Lab Partners created a series of 12 postcards centred around the adventures of a dachshund from Paris called Monsieur Boudin.

[DE] Lab Partners sind das Designer- und Illustratorenduo Sarah Labieniec und Ryan Meis. Labieniec besuchte erst die Rhode Island School of Design (RISD) und wechselte dann ans Ringling College of Art and Design, wo sie mit einem Bachelor of Fine Arts in Illustration abschloss. Am Ringling traf sie den Grafikdesign-Studenten Ryan Meis; nach dem Studienabschluss im Jahr 2008 zog das Paar nach San Francisco. Sie zeichnen für eine kontinuierliche Produktion von Illustrationen und Drucken verantwortlich, die vom Stil her an amerikanische Illustrationen aus der Mitte des 20. Jahrhunderts erinnern. Die Pressen- und Gocco-Drucke von Lab Partners haben über ihren Etsy-Shop eine wachsende Fangemeinde gefunden. 2009 gestalteten Lab Partners eine Serie von zwölf Postkarten, die von den Abenteuern eines Pariser Dackels namens Monsieur Boudin erzählen.

[FR] Le tandem designer-illustrateur de Lab Partners est né de l'association de Sarah Labieniec et Ryan Meis. Labieniec étudie à la Rhode Island School of Design (RISD) avant de parachever ses études au Ringling College of Art and Design, où elle décroche un Bachelor of Fine Arts en illustration. Elle rencontre sur le campus de Ringling l'étudiant en art graphique Ryan Meis et le couple part s'installer à San Francisco après avoir reçu leur diplôme en 2008. Ce duo approvisionne le marché d'un flot constant d'illustrations et de prints, dont le style ne va pas sans rappeler celui des illustrations américaines des années 50. Leur typo et leurs impressions Gocco ont révélé un véritable fan club grâce à leur plate-forme de vente en ligne Etsy. En 2009 Lab Partners a réalisé une série de 12 cartes postales centrées autour du personnage de teckel parisien, Monsieur Boudin.

[ES] El dúo de diseño e ilustración Lab Partners lo integran Sarah Labieniec y Ryan Meis. Labieniec inició sus estudios en la Rhode Island School of Design (RISD) y los concluyó en el Ringling College of Art and Design, donde se licenció en bellas artes, en la especialidad de ilustración. Fue en este último centro donde conoció a Ryan Meis, estudiante de diseño gráfico. Tras licenciarse en 2008, la pareja se trasladó a San Francisco. El dúo ha sido responsable de una producción constante de ilustraciones e impresiones caracterizadas por un estilo reminiscente de la ilustración estadounidense de mediados del siglo xx. Sus tipografías e impresiones con Gocco, que comercializan en su tienda Etsy, les han granjeado un fiel grupo de seguidores. En 2009, Lab Partners creó un conjunto de doce postales que narraban las aventuras de un perro salchicha parisino llamado Monsieur Boudin.

◄◄
Limited edition print for the exhibition
Hunt & Gather at the Outré Gallery in
Melbourne, Australia.

◄
Part of a series of four limited edition
prints. Inspired by summer breezes,
curious books and tiny companions.

▲
Part of a series of four limited edition
prints. Inspired by summer breezes,
curious books and tiny companions.

▲
Illustration for the UK-based magazine *Monocle* for an article on the future of retail.

▶
Limited edition print for the exhibition *Hunt & Gather* at the Outré Gallery in Melbourne, Australia.

Limited edition print for the exhibition *Hunt & Gather* at the Outré Gallery in Melbourne, Australia.

Illustration for the UK-based magazine *Monocle* to announce their new shop opening in Palma de Mallorca, Spain.

San Francisco – letterpress print.

Woodland – letterpress print. Client:
Hello!Lucky.

Seb Lester

www.seblester.co.uk
seb@seblester.co.uk

[EN] Seb(astian) Lester is a type designer and typographic illustrator, based in London where he studied graphic design at Central Saint Martins College of Art & Design. His first typefaces were released in the mid nineties by foundries such as T.26 and Garage Fonts, when he was still in college. Lester designed the Neo Sans, Scene, Soho and Soho Gothic typefaces, all published by Monotype where he works full time as a type designer on custom fonts. His typefaces are used by companies and publications as diverse as Dell, Intel, *The New York Times*, *The Sunday Times*, and *GQ Magazine*. Lester's recent limited edition typographic silk-screen prints, often drawing on historical sources, have been a big success and are in great contrast to his industrial typefaces.

[DE] Seb(astian) Lester ist Schriftdesigner und -illustrator und wohnt in London, wo er Grafikdesign am Central Saint Martins College of Art & Design studiert hat. Seine ersten Fonts erschienen Mitte der 90er-Jahre, noch zu seinen Collegezeiten, bei Foundrys wie T.26 und Garage Fonts. Lester entwarf die Schrifttypen Neo Sans, Scene, Soho und Soho Gothic, die alle bei Monotype herauskamen, wo er Vollzeit als Schriftdesigner für Custom Fonts zuständig ist. Unterschiedlichste Unternehmen und Publikationen wie Dell, Intel, *The New York Times*, *The Sunday Times* und *GQ Magazine* verwenden seine Schriften. Lesters kürzlich erschienene limitierte Auflage von typografischen Siebdrucken, die vielfach auf historische Quellen zurückgreifen, ist ein Riesenerfolg und setzt sich deutlich von seinen kommerziellen Schriften ab.

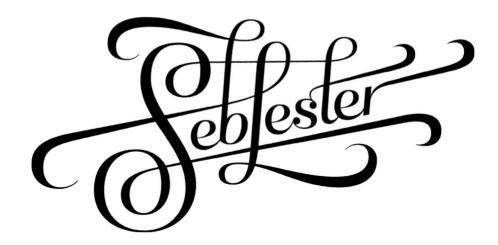

[FR] Lettriste et illustrateur-typographe, Seb(astian) Lester est basé à Londres où il a étudié le design graphique au Central Saint Martins College of Art and Design. Il crée ses premières polices (les fontes T.26 et Garage) alors qu'il est toujours sur les bancs de l'université. C'est également le créateur des fontes Neo Sans, Scene, Soho et Soho Gothic, toutes publiées par Monotype où il travaille à temps plein comme typographe spécialisé dans les fontes personnalisées. Ses polices de caractère sont utilisées par une grande variété d'entreprises et de publications telles que Dell, Intel, *The New York Times*, *The Sunday Times*, et *GQ Magazine*. Contrastant radicalement avec ses typos industrielles, sa dernière série de sérigraphies (édition limitée), souvent inspirée de sources historiques, a remporté un énorme succès.

[ES] Seb(astian) Lester es un tipógrafo e ilustrador tipográfico afincado en Londres, ciudad en la que estudió diseño gráfico, en el Central Saint Martins College of Art and Design. Publicó sus primeras tipografías a mediados de la década de 1990, con fundiciones como T.26 y Garage Fonts, cuando aún cursaba sus estudios universitarios. Lester ha diseñado las tipografías Neo Sans, Scene, Soho y Soho Gothic, todas ellas publicadas por Monotype, donde trabaja a jornada completa como tipógrafo creador de fuentes personalizadas. Sus tipografías las emplean empresas y publicaciones tan dispares como Dell, Intel, *The New York Times*, *The Sunday Times* y *GQ Magazine*. Las serigrafías tipográficas de edición limitada que Lester ha publicado recientemente, a menudo inspirándose en fuentes históricas, han tenido un éxito enorme y contrastan radicalmente con sus tipografías industriales.

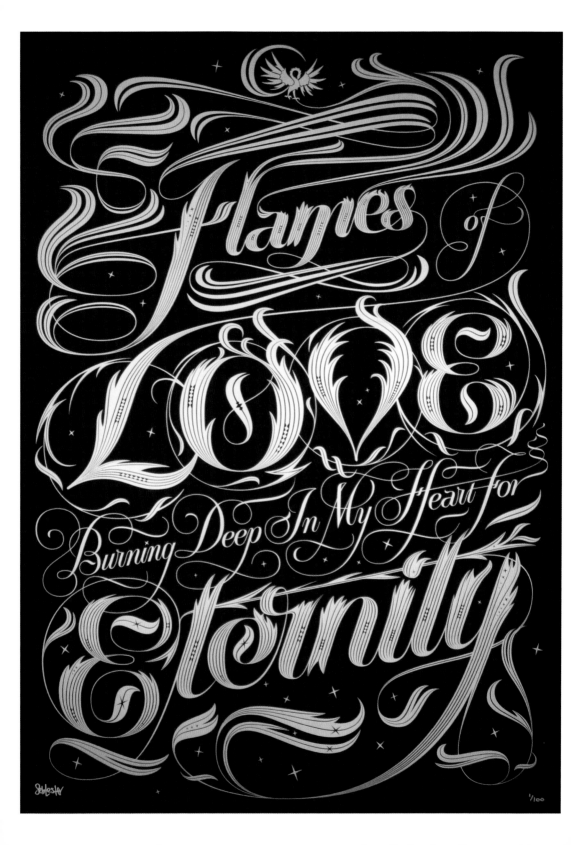

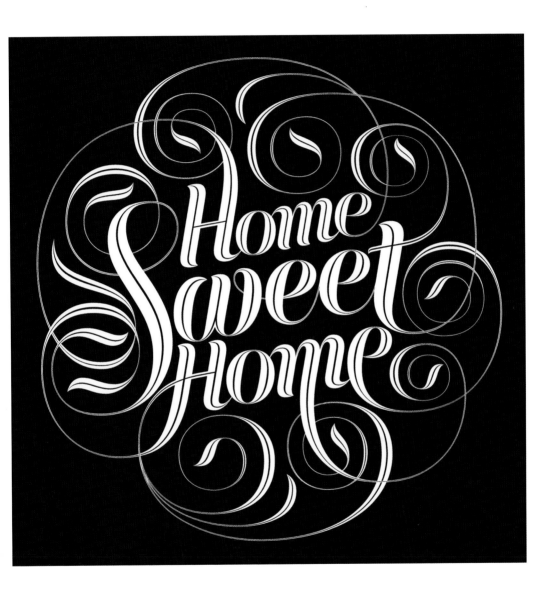

Seb Lester – personal logo.

◄
Flames – limited edition print.

▲
Home Sweet Home – limited edition print.

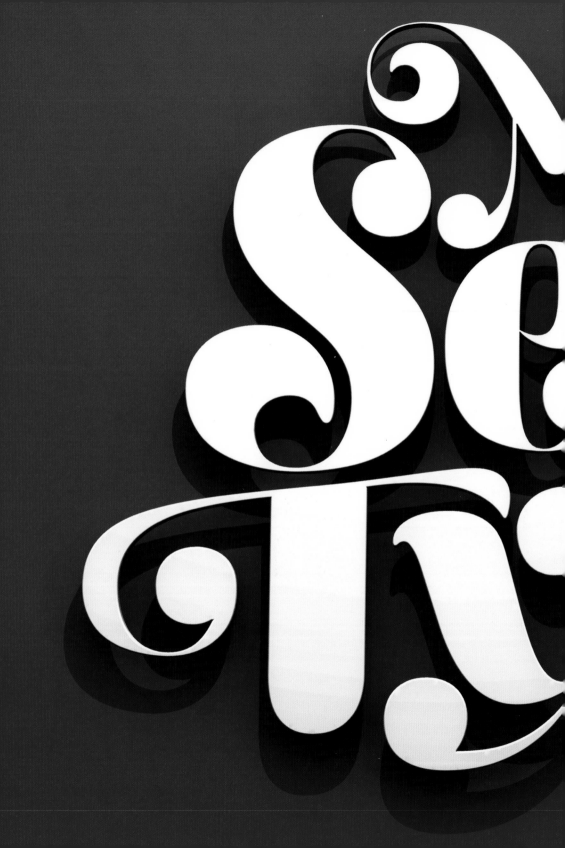

mm....

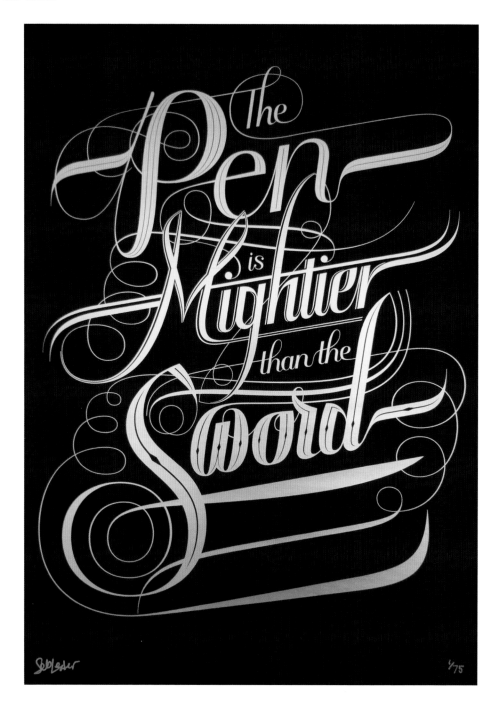

◄◄ *Mmm* – limited edition print.

▲ *Mightier* – limited edition print.

► *Believe* – limited edition print.

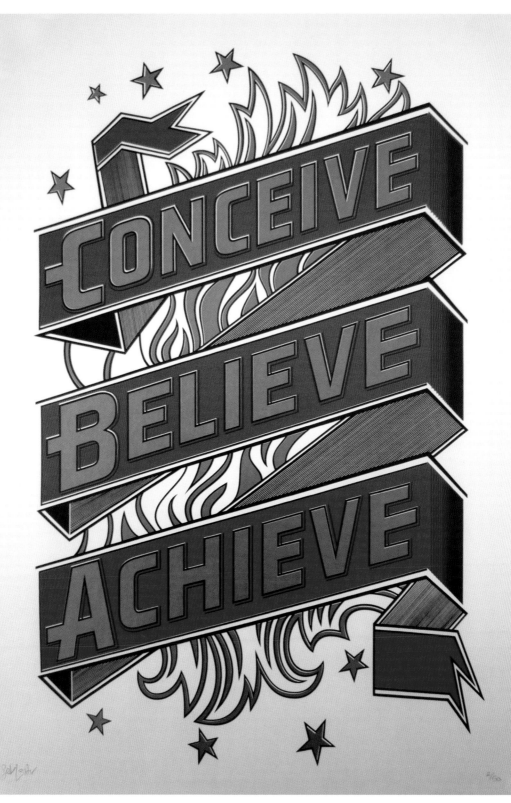

MAKI

www.makimaki.nl
info@makimaki.nl

[EN] MAKI consists of Kim Smits and Matthijs Maat, who are based in Groningen, the Netherlands. They met when they were students at Academy Minerva, School of Fine Art and Design, where Smits was studying illustration and Maat graphic design. After graduating in 2003 they decided to combine their skills and formed MAKI. They work for a wide variety of clients in the Netherlands and abroad. In 2008 the French Pyramyd Éditions published a book about the duo in its 'design&designer' series. One of MAKI's joint passions is customising shoes, which has resulted in the book *Custom Kicks*. Their second book, entitled *TEES*, was inspired by their own experience designing T-shirts for numerous companies from around the world. Both books have been published by Laurence King.

[DE] MAKI sind Kim Smits and Matthijs Maat aus Groningen, Niederlande. Sie lernten sich beim Studium an der Groninger Kunst- und Designschule Academie Minerva kennen, wo Smits Illustration studierte und Maat Grafikdesign. Nachdem sie das Studium 2003 abgeschlossen hatten, bündelten sie ihre Fähigkeiten und gründeten MAKI. MAKI arbeitet für die unterschiedlichsten Auftraggeber im In- und Ausland. 2008 veröffentlichten die französischen Pyramyd Éditions in ihrer „design&designer"-Reihe ein Buch über die beiden. Eine gemeinsame Leidenschaft beider MAKIs, die in ein *Custom Kicks* betiteltes Buch mündete, ist individuelles Gestalten von Schuhen. Ihr zweites Buch *TEES* entsprang Erfahrungen, die sie beim Entwerfen von T-Shirts für zahlreiche Unternehmen aus aller Welt sammelten. Beide Bücher erschienen bei Laurence King Publishing.

[FR] Installé dans les faubourgs de Groningue (Pays-Bas), le studio MAKI est né de l'association de Kim Smits et Matthijs Maat. Diplômés de l'Académie des Beaux-Arts Minerva en 2003 où ils étudient respectivement l'illustration et le graphisme, ils comptent parmi leurs clients de nombreuses entreprises aux Pays-Bas et à l'étranger. En 2008, la maison d'édition française Pyramyd leur consacre un livre dans sa collection « design&designer ». Fervents adeptes de la customisation de chaussures, Kim et Matthijs ont conjugué leur passion dans un livre intitulé *Custom Kicks*. Leur deuxième ouvrage, *TEES*, s'inspire de leur propre expérience internationale en tant que designers de tee-shirts. Ces deux livres ont été publiés par Laurence King.

[ES] MAKI lo integran Kim Smits y Matthijs Maat, ambos residentes en Groninga (Países Bajos). Se conocieron cuando estudiaban en la Academia Minerva, Escuela de Bellas Artes y Diseño, donde Smits era alumna de ilustración y Maat de diseño gráfico. Tras graduarse en 2003 decidieron combinar sus habilidades y constituyeron MAKI. Trabajan para un amplio abanico de clientes tanto de los Países Bajos como del extranjero. En 2008, la editorial francesa Pyramyd Editions publicó un libro sobre este dúo dentro de su serie «design&designer». Una de las pasiones que comparten los dos integrantes de MAKI es la personalización de zapatos, a raíz de la cual surgió el libro *Custom Kicks*. Su segundo libro, titulado *TEES*, se inspiró en su propia experiencia diseñando camisetas para numerosas empresas de todo el mundo. Ambos están publicados con la editorial Laurence King.

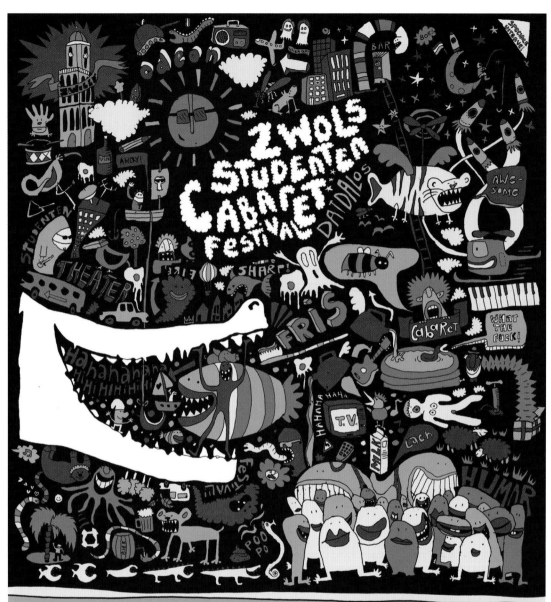

ZWOLS STUDENTEN CABARET FESTIVAL

**24 FEBRUARI
3 MAART
10 MAART**

HALVE FINALES

IN HET VLIEGENDE PAARD.
AANVANG OM 20.30 UUR.
ZAAL OPEN OM 20.00 UUR.

KAARTEN TE KOOP BIJ DE VVV, PLATO EN HET VLIEGENDE PAARD.
PRIJS: 3€

WWW.STUDERENINZWOLLE.NL

FINALE 23 MAART
SCHOUWBURG ODEON

◄◄
Customised trainers. Personal work.

◄
Poster for student cabaret festival.
Client: Stichting Daidalos.

▲
Little Red Riding Hood Wanted – poster
for Red Ribbon Rock festival.

▲
Summer Happy Hour – flyer. Client: Charlie P's.

▶▲
Our Mom is a Hot Chick – T-shirt design. Personal work.

▶
First Aid – T-shirt design. Personal work.

Customised Converse All Stars.
Commissioned work.

Long Hot Summer – shoe design.
Client: The String Republic.

Magic is an Illusion – T-shirt design.
Client: Teefury.

weezer

Faces – T-shirt design. Client: Weezer.

Storefront and logo. Corporate identity for the sandwich bar Naked Lunch in Vienna, Austria.

Folding poster for *Architecture Day 2008* in Groningen, the Netherlands.

Misprinted Type

www.misprintedtype.com
recife@misprintedtype.com

[EN] Eduardo Recife is a type designer, illustrator, graphic designer, photographer and collage artist from Belo Horizonte, Brazil. He is best known for his distressed typefaces, which are part of what most people would call the 'grunge' aesthetic. Recife's typographic fascination started with street art like graffiti. After meeting a group of artists who were creating their own fonts, he decided to translate these and other forms of street lettering into digital typefaces and started his own foundry, Misprinted Type, in 1998. Recife uses his own font creations for commercial and personal work, fusing the street aesthetic with vintage images to create his characteristic style. His clients have included *The New York Times*, TCM (Turner Classic Movies), HBO, GNU Snowboards and Gigolo Records.

[DE] Eduardo Recife ist ein Schriftdesigner, Illustrator, Grafikdesigner, Fotograf und Collagekünstler aus Belo Horizonte, Brasilien. Am bekanntesten ist er für seine Schriften im Antik-Look, die man am ehesten der so genannten Grunge-Ästhetik zuordnen würde. Recifes Faszination für Schriften begann mit Straßenkunst, z. B. Graffiti. Nachdem er eine Gruppe von Künstlern kennen gelernt hatte, die eigene Fonts entwarfen, beschloss er, diese und andere Formen von Straßentypografie in digitale Schriften umzusetzen und gründete 1998 seine eigene Foundry, Misprinted Type. Recife benutzt selbstentworfene Schriften für seine kommerziellen und persönlichen Arbeiten, deren ganz persönlicher Stil sich einer Fusion aus Straßenästhetik mit altem Bildmaterial verdankt. Unter seinen Auftraggebern waren bisher *The New York Times*, TCM (Turner Classic Movies), HBO, GNU Snowboards und Gigolo Records.

[FR] Originaire de Belo Horizonte, au Brésil, Eduardo Recife est à la fois typographe, illustrateur, designer graphique, photographe et collagiste. Il doit son succès à ses typos déformées qui font partie de ce que la plupart considèrent comme son univers esthéthique « grunge ». Sa fascination pour la typographie est née de l'art de la rue et plus particulièrement des graffitis. Sa rencontre avec un groupe d'artistes créateurs de leurs propres fontes, l'amène à convertir leurs polices ainsi que d'autres formes de tags en typos digitales. Ce faisant, il crée en 1998 sa propre fonderie, Misprinted Type. Recife marie ses propres fontes à ses réalisations commerciales et personnelles, faisant fusionner l'esthétique urbaine et les images vintage pour former ce style qui lui est propre. Il compte parmi ses clients *The New York Times*, TCM (Turner Classic Movies), HBO, GNU Snowboards et Gigolo Records.

[ES] Eduardo Recife es un tipógrafo, ilustrador, diseñador gráfico, fotógrafo y artista de collage nacido en Belo Horizonte (Brasil). Es conocido principalmente por sus tipografías ajadas, que la mayoría asociaríamos a una estética grunge. La fascinación de Recife por la tipografía surgió de su afición al arte urbano, al grafiti concretamente. Tras conocer a un grupo de artistas que creaban sus propias fuentes, decidió traducir estas y otras formas de rotulación callejera en tipografías digitales y en 1998 creó su propia fundición, Misprinted Type. Recife utiliza fuentes de su propia creación para sus trabajos comerciales y personales; en ellas fusiona la estética de las calles con imágenes retro, gracias a lo cual se ha forjado un estilo muy peculiar. Entre sus clientes figuran *The New York Times*, TCM (Turner Classic Movies), HBO, GNU Snowboards y Gigolo Records.

Judge Not. Personal work.　　*You are Trapped*. Personal work.　　*Where did Hope Go?* Personal work.

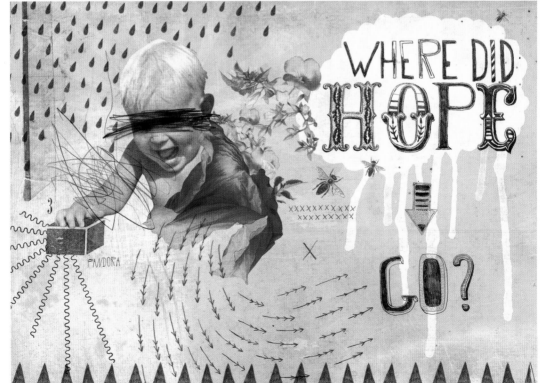

Patryk Mogilnicki

www.patryk.carbonmade.com
pa.tryk@yahoo.com

[EN] Patryk Mogilnicki was born in Poznań, Poland, and received his degree in graphic arts from the Academy of Fine Arts in Poznań with a distinction in lithography. In 2005 he moved to Warsaw where he divides his time between illustration, photography and graphic design. His illustrations have been published in major Polish magazines, like *Wysokie Obcasy* (the Saturday supplement of the largest Polish daily newspaper) and *FILM* (Polish film magazine), as well as the Polish editions of *Max*, *Newsweek* and *Playboy*. In 2008 Mogilnicki received a silver award during the Polish National Advertising Fair for one of his editorial illustrations for the Polish edition of *Playboy*. He also designs CD covers for several indie bands, among them Shame On You, in which he plays the drums.

[DE] Patryk Mogilnicki, geboren im polnischen Posen, schloss sein Studium der freien Grafik an der Kunsthochschule Posen mit Auszeichnung in Lithografie ab. 2005 zog er nach Warschau um, wo er sowohl als Illustrator als auch als Fotograf und Grafikdesigner arbeitet. Seine Illustrationen erscheinen in wichtigen polnischen Periodika wie *Wysokie Obcasy* (die Samstagsbeilage der größten polnischen Tageszeitung) und *FILM* (polnische Filmzeitschrift) sowie in den polnischen Ausgaben von *Max*, *Newsweek* und *Playboy*. 2008 erhielt Mogilnicki eine Silbermedaille der Polnischen Nationalen Werbemesse für eine seiner Illustrationen im polnischen *Playboy*. Er gestaltet auch CD-Covers für etliche Indie-Gruppen, darunter Shame On You, in der er selbst Schlagzeug spielt.

[FR] Titulaire d'un diplôme en arts graphiques de l'Académie des Beaux-Arts de Poznań avec mention très bien en lithographie, Patryk Mogilnicki est né à Poznań, en Pologne. En 2005, il part s'installer à Varsovie où il partage son temps entre l'illustration, la photographie et le design graphique. Il compte parmi ses clients des magazines polonais de renom comme *Wysokie Obcasy* (supplément de l'édition du samedi du plus grand quotidien polonais) et *FILM* (revue cinématographique polonaise), ainsi que les éditions polonaises de *Max*, *Newsweek* et *Playboy*. En 2008, Mogilnicki s'est vu décerner un Silver Award au cours de la National Advertising Fair en Pologne pour l'une de ses illustrations éditoriales parues dans l'édition polonaise de *Playboy*. Il réalise également des jaquettes CD pour plusieurs groupes de musique indépendants, et notamment Shame On You, dont il est le batteur.

[ES] Patryk Mogilnicki nació en Poznan (Polonia) y se licenció en artes gráficas por la Academia de Bellas Artes de Poznan, con matrícula de honor en litografía. En 2005 se trasladó a Varsovia, donde reparte su tiempo entre la ilustración, la fotografía y el diseño gráfico. Sus ilustraciones se han publicado en las principales revistas polacas, entre ellas *Wysokie Obcasy* (el suplemento de los sábados del diario polaco de mayor tirada) y *FILM* (una publicación sobre cine), así como en las ediciones polacas de *Max*, *Newsweek* y *Playboy*. En 2008, Mogilnicki recibió un premio de plata durante la Feria Polaca de Publicidad por una de sus ilustraciones para la edición polaca de *Playboy*. También diseña carátulas de CD para diversas bandas de música independiente, entre ellas Shame On You, en la que él mismo toca la batería.

Illustration for the Polish magazine *Exklusiv* for an interview with the Ukrainian writer Serhij Żadan.

CD cover for the band Shame On You. www.myspace.com/shameonyouband

Illustration for the Polish edition of *Playboy* for an article on Damien Hirst.

◄
Poster for a series of performances
under the title *Endangered Species* by
the Warsaw improv theatre Klancyk.

▲
Illustration for the Polish women's
magazine *Wysokie Obcasy* for an article
on infant behaviour.

Illustration for the Polish women's magazine *Wysokie Obcasy* for an article on pregnancy and diabetes.

Illustration for the Polish edition of *Playboy* for an article on suicide.

Janine Rewell

www.janinerewell.com
janine@janinerewell.com

[EN] Janine Rewell is a freelance graphic designer and illustrator who lives in Helsinki, Finland, where she also attended the University of Art and Design Helsinki (UIAH). After graduating in graphic design and illustration, she attended the Rhode Island School of Design (RISD). Since 2006 Rewell has been active as an illustrator and has won several awards for her work, including a bronze Design Lion at the 2009 Cannes Lions International Advertising Festival. Obviously inspired by the geographical location of Finland, her vector illustrations represent an original mix of Slavic folk art and modern Scandinavian design. Despite the 'local' inspiration of Rewell's work, it attracts clients outside of Finland and has resulted in publications in numerous books and magazines.

[DE] Janine Rewell, Freelance-Grafikde-signerin und -Illustratorin, lebt in Helsinki, Finnland, wo sie die Kunst- und Design-hochschule Helsinki (UIAH) besuchte. Nach ihrem Abschluss in Grafikdesign und Illustra-tion ging sie an die Rhode Island School of Design (RISD). Seit 2006 arbeitet Rewell als Illustratorin und gewann mit ihren Arbei-ten mehrere Preise, u. a. einen bronzenen Design-Löwen auf dem Cannes Lions International Advertising Festival 2009. Ihre eindeutig vom finnischen Kontext beeinflussten Vektorillustrationen prägt ein origineller Mix aus slawischer Volkskunst und modernem skandinavischen Design. Obwohl Rewells Arbeiten „ortsspezifisch" inspiriert sind, stoßen sie auch bei Kunden von außerhalb Finnlands auf reges Interesse und sind in mehreren Büchern und Magazi-nen vorgestellt worden.

[FR] Designer graphique et illustratrice free-lance, Janine Rewell vit à Helsinki, en Finlande. Diplômée en design graphique et illustration de l'UIAH (University of Art and Design Helsinki), elle suit ensuite des cours à la Rhode Island School of Design (RISD). Depuis 2006, Rewell travaille comme illustratrice ; ses travaux lui ont valu de nombreuses récompenses dont le Lion de bronze dans la catégorie Design au Festival International de la publicité de Cannes de 2009 (Cannes Lions International Advertising Festival). Manifestement inspirées de la position géographique de la Finlande, ses illustrations vectorielles représentent un mélange original d'art populaire slave et de design scandinave moderne. En dépit de cette inspiration « couleur locale », le travail de Rewell attire une vaste clientèle bien au-delà des frontières finlandaises et a fait l'objet de publications dans de nombreux livres et magazines.

[ES] Janine Rewell es una ilustradora y diseñadora gráfica freelance afincada en Helsinki (Finlandia), la misma ciudad donde estudió, concretamente en la Universidad de Arte y Diseño de Helsinki (UIAH). Tras licenciarse en diseño gráfico e ilustración, prosiguió sus estudios en la Rhode Island School of Design (RISD). Desde 2006, Rewell ha trabajado como ilustradora y ha ganado varios premios por su obra, incluido un león de bronce al diseño en la edición de 2009 del Festival Internacional de Publicidad Cannes Lions. Claramente inspiradas en la ubicación geográfica de Finlandia, sus ilustraciones vectoriales suponen una original mezcla de arte folclórico eslavo con diseño escandinavo moderno. Pese a la inspiración «local» de su obra, Rewell cuenta con clientes fuera de Finlandia y ha publicado en numerosos libros y revistas.

◄◄
Trip to Volga – illustration for the Finnish magazine *Mondo*. Client: Imagekustannus.

▲
Expanding to the Russian Market – illustration for the cover of the Finnish magazine *Lindorff*.

►
Expanding to the Russian Market – illustration (detail) for the Finnish magazine *Lindorff*.

◄
City Life and Urban Aesthetics – interior fabric (detail) used in the main exhibition hall. Client: Helsinki Design Week.

▲
Valentine's Day postage stamps. Client: Itella Oyj.

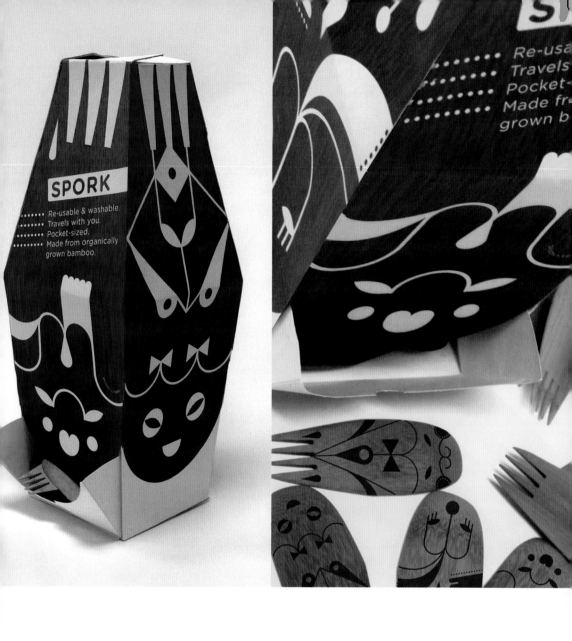

SPORK

·····• Re-usable & washable.
·····• Travels with you.
·····• Pocket-sized.
·····• Made from organically
grown bamboo.

◄
City Life and Urban Aesthetics – interior
fabric (detail) used in the main exhibition
hall. Client: Helsinki Design Week.

▲
Decoration and a counter-top packaging
design for bambu utensils produced by
Bambuhome. Assignment at RISD.

►►
Illustration for an invitation for the Milan
showroom of the Finnish textiles and
clothing design company Marimekko.

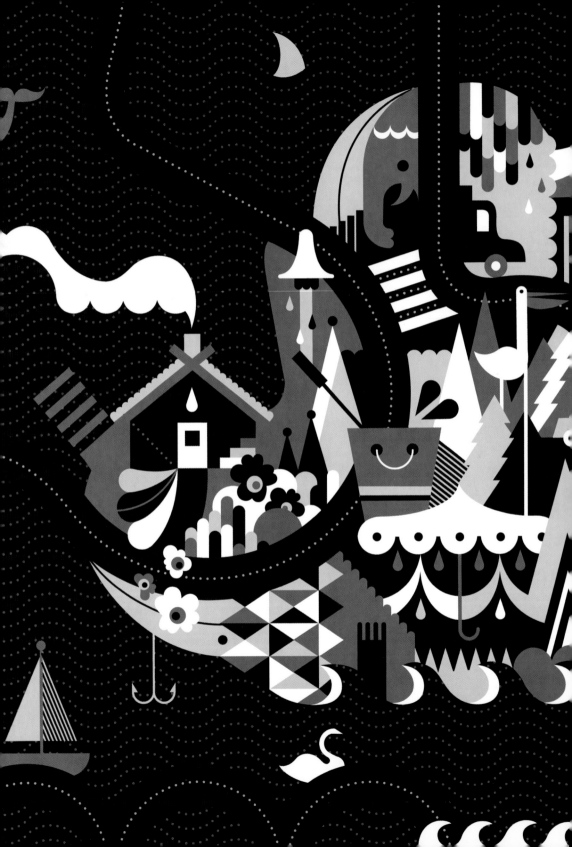

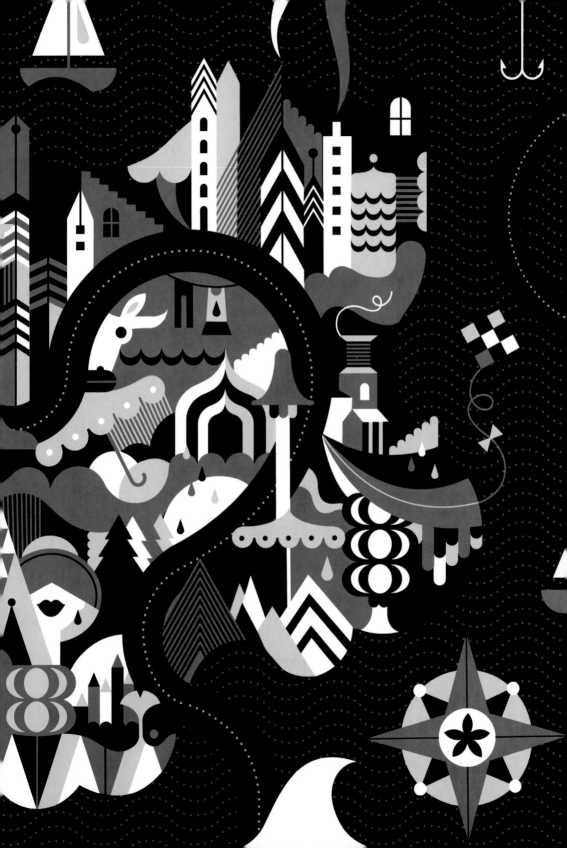

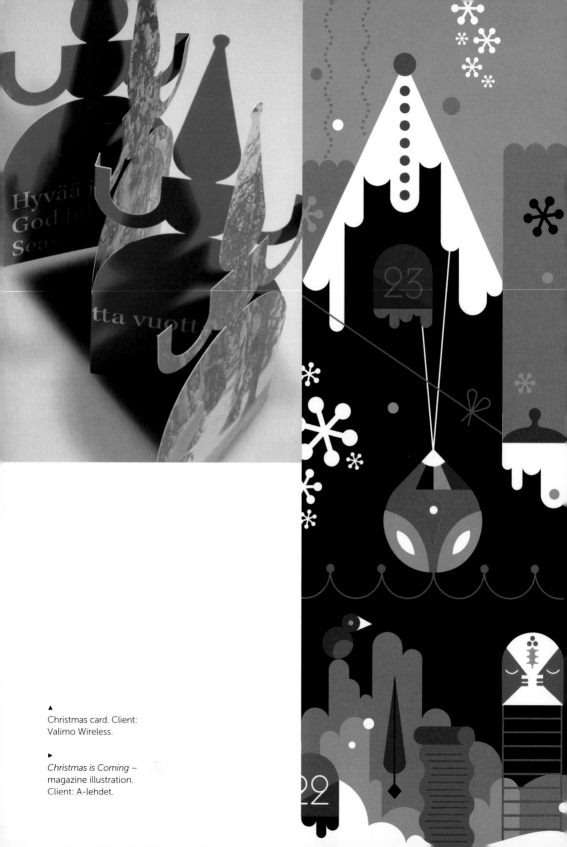

▲
Christmas card. Client:
Valimo Wireless.

►

Christmas is Coming –
magazine illustration.
Client: A-lehdet.

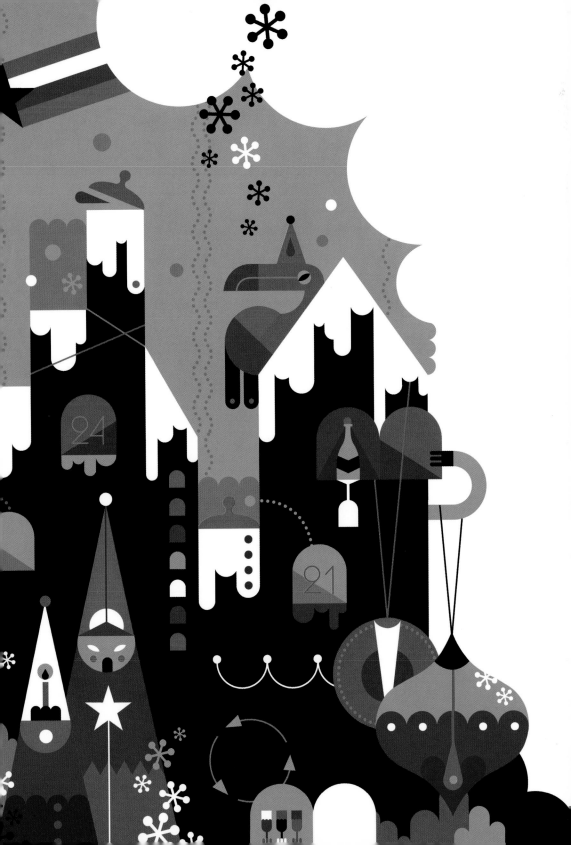

Nicolas Robel

www.bulbfactory.ch/nicolas
nicolasrobel@bulbfactory.ch

[EN] Nicolas Robel was born in Quebec, Canada, but moved with his family at the age of three to Geneva, Switzerland, where he now lives and works as a graphic designer and illustrator. After receiving his diploma in visual communication from the School of Applied Arts (HEAD) in Geneva, Robel started publishing graphic novels and other picture books under the name B.ü.L.b comix. In addition to his own books, like *Joseph*, he publishes work by other sequential artists. In 1999 he opened his own design studio, B.ü.L.b grafix. His books have been published in French, English, German and Polish. In 2005 he had a solo exhibition during the Fumetto festival in Lucerne, Switzerland, entitled 'How Should I Know', for which occasion a modest monograph was published under the same title.

[DE] Nicolas Robel, geboren im kanadischen Quebec, zog im Alter von drei Jahren mit seiner Familie ins schweizerische Genf, wo er als Grafikdesigner und Illustrator arbeitet. Nach einem Diplomabschluss in visueller Kommunikation an der Genfer Haute École d'Art et de Design (HEAD) begann Robel unter dem Namen B.ü.L.b comix Graphic Novels und andere Comicbücher zu veröffentlichen. Neben eigenen Titeln wie *Joseph* publiziert er auch Arbeiten anderer Comic-Künstler. 1999 eröffnete er sein eigenes Designstudio B.ü.L.b grafix. Seine Bücher erscheinen auf Französisch, Englisch, Deutsch und Polnisch. 2005 hatte er beim Fumetto Comix Festival in Luzern eine Soloausstellung mit dem Titel „How Should I know", zu der eine kleine Monografie mit gleichem Titel erschien.

[FR] Originaire de Québec, Nicolas Robel quitte le Canada à l'âge de trois ans avec sa famille pour s'installer en Suisse, à Genève, où il réside actuellement et travaille comme designer graphique et illustrateur. Diplôme de communication visuelle à la Haute École d'Art et de Design (HEAD) de Genève en main, Robel se lance dans la publication de romans graphiques et autres albums sous le pseudonyme de B.ü.L.b comix. Il publie outre ses propres ouvrages (*Joseph*), les travaux d'autres scénaristes de bandes dessinées. En 1999, il crée sont propre studio de design, B.ü.L.b grafix. Il est édité en français, en anglais, en allemand et en polonais. En 2005, le Fumeto festival de Lucerne lui consacre une exposition personnelle intitulée « How Should I Know » à l'issue de laquelle il publie une petite monographie, sorte de carnet intime, sous le même titre.

[ES] Nicolas Robel nació en Quebec (Canadá), pero emigró junto con su familia a Ginebra (Suiza) cuando solo tenía tres años de edad. Allí vive y trabaja como diseñador gráfico e ilustrador. Tras licenciarse en comunicación visual por la Escuela de Artes Aplicadas (HEAD) de Ginebra, Robel empezó a publicar novelas gráficas y otros libros de imágenes bajo el nombre de B.ü.L.b comix. Además de sus propios libros, como *Joseph*, publica la obra por fascículos de otros artistas. En 1999 fundó su estudio de diseño, B.ü.L.b grafix. Sus libros se han editado en francés, inglés, alemán y polaco. En 2005 realizó una exposición individual durante el festival Fumeto en Lucerna titulada «How Should I Know», para la cual se editó una modesta monografía con el mismo título.

Restaurant Kino Hotel

Royal

Schwarzwaldallee 179, 4058 Basel
061 686 55 91 www.kino-royal.ch

BRUCKI PFANNENSTIL

Mi-Fr 14-18h
Sa 10-16h

Laubisrütistr. 50

Tel. 044 / 926 50 60

8712 Stäfa

Rindermarkt. 23, 8001 Zürich
Tel 01-2622

R/AZZO
SECOND HAND

CRAZYbeat

Vinyl, CDs, 12", Import, Occasionen
Badenerstr. 79, 8004 Zürich
Tel. 044 241 10 17
Fax 044 291 53 27
e-mail: info@crazybeat.ch
web: www.crazybeat.ch

Chateau de Faverolles

Recording Studios

F-52260 Faverolles
Tel: 0033 (0)3 25 84 43 21

www.chateaudefaverolles.com

Tel. 044 491 96 82

Edition moderne

Eglistrasse 8, 8004 Zürich

LINDWURM
BUCHHANDLUNG

Rue de Lausanne 41
1700 Fribourg

Tel. 026 - 322 31 65
Fax 026 - 322 07 18
www.lindwurm.ch
info@lindwurm.ch

Zähringerplatz 11 8001 Zürich
Tel. 01 / 252 05 00

ZÄHRINGER
RESTAURANT-CAFÉ

ARCHITEKTUR &
DESIGN

Brungasse 60
CH-3011 Bern
Tel. 031 / 311 15 17
www.architektur-buchhandlung.ch

THE
BOOK
YOU
NEED

kanonengasse 20 8004 zürich

VIDEOEX
experimentalfilm
und videofestival
19.-29. mai 2005

www.videoex.ch

Bar Kultur Restaurant

Chramerhuus

Jurastr.12, 4900 Langenthal
062 / 923 15 50. Fax 062 / 922 88 22
Mo-Fr17-0.30h Sa/Soi 12-0.30h
Fr + Sa offen bis 2 Uhr
info@nachtstuecke.com
www.nachtstuecke.com

masi

◄◄
Illustration for the Swiss magazine *Vivre à Genève*.

◄
Twelve ads/stickers for the German comic magazine *Strapazin*.

▲
Phong Ping 18, 23 and 15 Years Old – illustration for the Swiss Sunday newspaper *Dimanche.ch*.

◄

1 2 3 4 5 6 Töpffer –
DVD cover. Client:
Département de la
culture de la Ville de
Genève.

▶

Illustration for *La Pravda*, a guide to
summer music festivals. Client: Couleur 3,
Radio Suisse Romande.

▶▶

Get Well – postcard.
Client: Roche.

Top: *Sorry* – postcard. Bottom: *Holidays* – postcard. Client: Roche.

▲
Paper shopping bag to promote the Fumetto Comic Festival in Lucerne, Switzerland. Client: Migros Kulturprozent.

►
Press ad. Client: Migros Kulturprozent.

◄

10th Anniversary of Éditions de la Pastèque – illustration. Client: Éditions de la Pastèque.

▲

Exquisite Corpse – set of ten (four shown) postcards. Published by B.ü.L.b Comix.

Shamrock

www.shamrocking.com
shamrock@shamrocking.com

[EN] Shamrock, a.k.a. Jeroen Klaver, is a Dutch graphic designer and illustrator. One of his most visible projects has been the identity for the Dutch classification system for films, TV films and DVDs. Every DVD bought in the Netherlands carries his icons, and before watching any film, viewers will see one of the animations he has created. For Boomerang, a publisher of free postcards, Klaver has been designing cards for over a decade. He has also provided workshops promoting social communication at the Nola Hatterman Art Academy in Paramaribo, Suriname, for the non-profit organisation Good 50x70. Characteristic of most of Klaver's work is the total integration of typography and image, which is possible thanks to the typefaces he creates for his own projects, as well as his lettering skills.

[DE] Shamrock alias Jeroen Klaver ist ein niederländischer Grafikdesigner und Illustrator. Eines seiner profiliertesten Projekte ist die visuelle Identität des niederländischen Klassifikationssystems für Kino- und TV-Filme und DVDs. Auf jeder in den Niederlanden gekauften DVD prangen seine Icons und vor jedem Film sieht man erst einmal eine seiner Animationen. Klaver gestaltet sein über zehn Jahren auch Karten für den Gratispostkarten-Verlag Boomerang. Außerdem hat er für die Non-Profit-Organisation Good 50x70 Workshops zur Förderung von sozialer Kommunikation an der Nola Hatterman Art Academy in Paramaribo, Suriname, gegeben. Typisch für die meisten Klaver-Arbeiten ist die absolute Integration von Typografie und Bild, die sich nicht nur seinem typografischen Fingerspitzengefühl, sondern auch der Tatsache verdankt, dass er die Schriften für seine Projekte selbst entwirft.

[FR] Shamrock, alias Jeroen Klaver, est un designer graphique et illustrateur néerlandais. Sa contribution la plus visible a été celle au système néerlandais de classification des médias audiovisuels (films, téléfilms et DVD). Chaque DVD acheté aux Pays-Bas présente ses icônes ; de la même façon, avant de visualiser un film, quel qu'il soit, les spectateurs néerlandais peuvent admirer l'une de ses animations. Depuis plus d'une dizaine d'années, il conceptualise des cartes postales pour l'éditeur de cartes postales publicitaires gratuites, Boomerang. Il a également animé des ateliers de promotion de la communication sociale à la Nola Hatterman Art Academy de Paramaribo, au Suriname, pour le compte de l'organisation caritative Good 50x70. La majorité des travaux de Klaver se distinguent par leur intégration totale de l'écriture graphique et de l'image, résultat de fontes créées de toutes pièces et de son talent de lettreur.

[ES] Shamrock, alias Jeroen Klaver, es un ilustrador y diseñador gráfico holandés. Uno de sus proyectos más visibles ha sido la identidad para el sistema de clasificación holandés de películas de cine y televisión y DVD. Cada DVD comprado en los Países Bajos luce sus iconos y antes de ver una película los espectadores ven las animaciones que Klaver ha creado. Además, lleva más de una década diseñando postales para Boomerang, una editorial dedicada a este campo. También ha impartido seminarios de fomento de la comunicación social en la Academia de Arte Nola Hatterman de Paramaribo (Surinam) para la organización sin ánimo de lucro Good 50x70. La obra de Klaver se caracteriza por la total integración de tipografía e imagen, posible gracias a las fuentes que él mismo diseña para sus proyectos, así como a sus excelentes dotes para el rotulado.

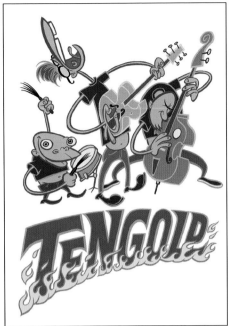

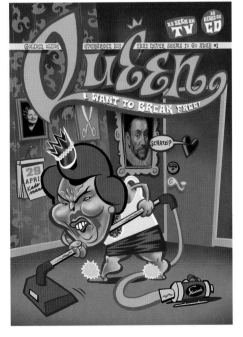

◄◄

Shamrock – personal logo.

◄

Cover for a brochure explaining how to create Boomerang Freecards that are fun. Client: Boomerang Freecards.

▲

A selection of several postcards for Boomerang Freecards.

A selection of several postcards for Boomerang Freecards.

Inside page for a brochure explaining how to create Boomerang Freecards that are fun. Client: Boomerang Freecards.

SPELREGELS VOOR DE ACHTERKANT

IN TEGENSTELLING TOT EEN AFFICHE OF EEN TIJDSCHRIFTENADVERTENTIE IS EEN ANSICHTKAART DUBBELZIJDIG. INFORMATIE VAN HUISHOUDELIJKE AARD, ZOALS EEN ADVIESPRIJS OF EEN TELEFOONNUMMER, HOEVEN HET ARTWORK OP DE VOORKANT NIET ONNODIG TE ONTSIEREN. PLAATS DAT SOORT TEKST OP DE ACHTERKANT, MAAR ZORG ER ALTIJD VOOR DAT JE DE POTENTIËLE GEBRUIKER NIET DE RUIMTE ONTNEEMT JOUW KAART LEKKER TE BESCHRIJVEN. EEN EN ANDER MOET PASSEN BINNEN EEN (DENKBEELDIG) KADER VAN MAXIMAAL 25 x 60 MM.

SCHROOM NIET TE BELLEN ALS JE MEER WILT WETEN OVER BOOMERANG. WE STAAN JE GRAAG TE WOORD.

TELEFOON 020-460 90 40
FAX 020-460 90 41
EMAIL info@boomerang.nl

Boomerang Media
BEZOEK Willem Fenengastraat 16
POST Postbus 763
1000 AT Amsterdam

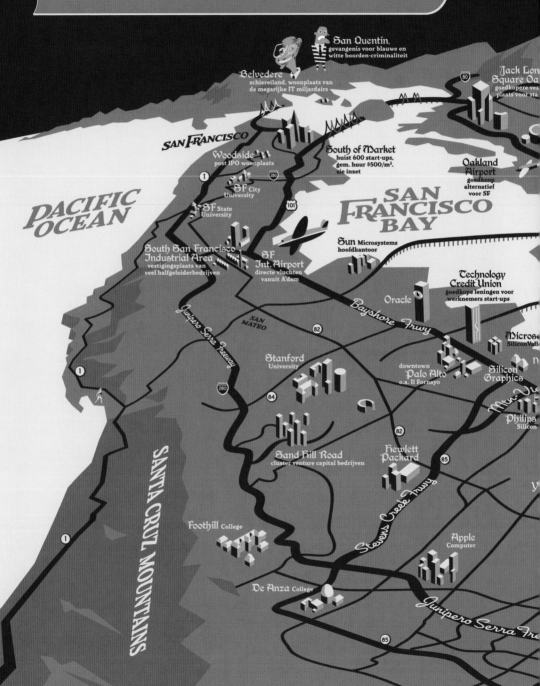

San Jose / Silicon Valley

San Quentin, gevangenis voor blauwe en witte boorden-criminaliteit

Jack Lon Square Oa goedkopere ves plaats voor sta

Belvedere schiereiland, woonplaats van de megarijke IT miljardairs

SAN FRANCISCO

Woodside post IPO woonplaats

South of Market huist 600 start-ups, gem. huur $500/m². zie inzet

Oakland Airport goedkoop alternatief voor SF

SF City University

SF State University

PACIFIC OCEAN

SAN FRANCISCO BAY

South San Francisco Industrial Area vestigingsplaats van veel halfgeleiderbedrijven

SF Int. Airport directe vluchten vanuit A'dam

SUN Microsystems hoofdkantoor

Technology Credit Union goedkope leningen voor werknemers start-ups

Oracle

Juniper Serra Freeway

SAN MATEO

Bayshore Frwy

Micros SiliconVall

Stanford University

downtown **Palo Alto** o.a. Il Fornaio

Silicon Graphics

n

Mtn-Vi

Philips Silicon

Sand Hill Road cluster venture capital bedrijven

Hewlett Packard

Stevens Creek Frwy

SANTA CRUZ MOUNTAINS

Foothill College

Apple Computer

De Anza College

Junipero Serra Fre

y

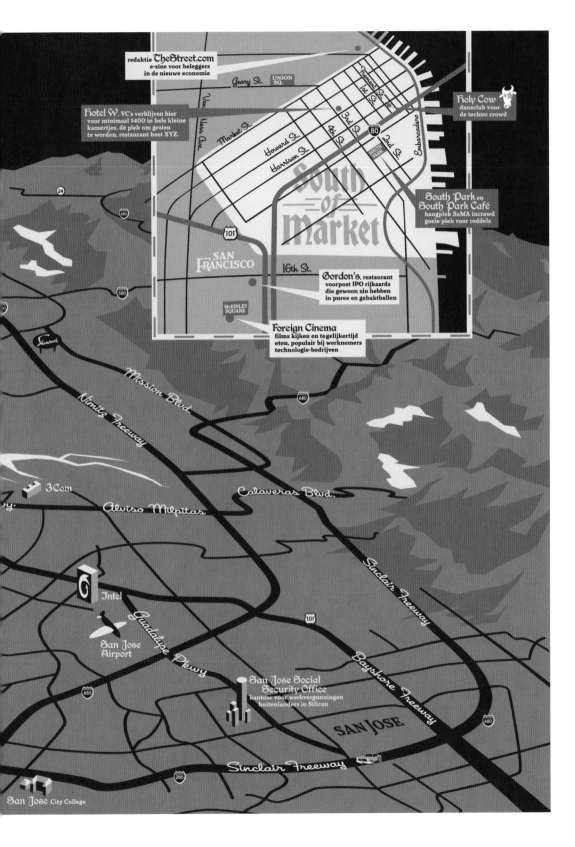

redaktie TheStreet.com
e-zine voor beleggers
in de nieuwe economie

Geary St. UNION SQ.

Holy Cow
dansclub voor
de techno crowd

Hotel W, VC's verblijven hier
voor minimaal $400 in hele kleine
kamertjes, dé plek om gezien
te worden, restaurant heet XYZ.

Market St.
Howard St.
Harrison St.

80

SOUTH PARK

Embarcadero

South of Market

South Park en
South Park Café
hangplek SoMA incrowd
goeie plek voor roddels

101

SAN FRANCISCO

16th St.

Gordon's, restaurant
voorpost IPO rijkaards
die gewoon zin hebben
in puree en gehaktballen

McKINLEY SQUARE

Foreign Cinema
films kijken en tegelijkertijd
eten, populair bij werknemers
technologie-bedrijven

24

680

580

Shamrock

Mission Blvd.

680

3Com

Calaveras Blvd.

Nimitz Freeway

Alviso Milpitas

Sinclair Freeway

Intel

Guadalupe Pkwy

101

San Jose Airport

Bayshore Freeway

680

880

San Jose Social
Security Office
kantoor voor werkvergunningen
buitenlanders in Silicon

SAN JOSE

Sinclair Freeway

280

San Jose City College

◄◄
Silicon Valley map for the Dutch maga-
zine *Internet In Business*. Client: Marc
van Meurs.

◄
Poster promoting the new CD of the
Blue Grass Boogiemen.

▲
Illustration/logo for the column *Yasha*
in the Dutch TV guide *VPRO Gids*.

◀

Poster/flyer for the
Swiss music festival
Stolzewiese. Client:
Stolze Open Air.

▶

Magazine Party –
poster for a party
aimed at people
working in the Dutch
magazine business.
Client: Totempaal
Media.

Andy Smith

www.asmithillustration.com
andy@asmithillustration.com

[EN] Andy Smith is an illustrator and lettering artist living and working in Hastings, England. Since graduating from the Royal College of Art in London, he has worked for a wide range of UK and international clients, including Nike, Orange, McDonalds, *The Guardian*, *Time Out*, Random House, Penguin Books and Nickelodeon. His advertising, print, publishing and animation work has received D&AD, AOI and Creative Circle awards. Alongside his commercial projects he creates silk-screen printed books and posters that are available through his own website and selected galleries. Smith's works have been included in exhibitions in the UK, France, USA, Italy, Japan and Australia. Even though he creates most of his art with the aid of a computer, he maintains a distinctly handmade feel.

[DE] Andy Smith, Illustrator und Schriftkünstler, lebt und arbeitet im englischen Hastings. Seit Abschluss seines Studiums am Royal College of Art in London arbeitet er für eine breite Auswahl von britischen und ausländischen Auftraggebern, darunter Nike, Orange, McDonalds, *The Guardian*, *Time Out*, Random House, Penguin Books and Nickelodeon. Seine Werbe-, Druck-, Verlags- und Animationsarbeiten wurden mit Preisen des D&AD, AOI und Creative Circle gewürdigt. Neben kommerziellen Projekten stellt er auch Bücher im Siebdruck sowie Poster her, die er über die eigene Website und ausgewählte Galerien vertreibt. Smiths Arbeiten wurden in Ausstellungen in Großbritannien, Frankreich, den USA, Italien, Japan und Australien gezeigt. Obwohl die meisten seiner Werke mit Hilfe des Computers entstehen, wirken sie definitiv wie von Hand gemacht.

[FR] Illustrateur et artiste lettreur, Andy Smith réside et travaille à Hastings, en Angleterre. Diplômé du Royal College of Art de Londres, il a depuis travaillé pour une clientèle variée en Angleterre et à l'étranger, y compris Nike, Orange, McDonalds, *The Guardian*, *Time Out*, Random House, Penguin Books et Nickelodeon. Il a été récompensé pour son travail dans le domaine de la pub, du « print », de l'édition et de l'animation par un D&AD, AOI and Creative Circle Award. Parallèlement à ses projets commerciaux, il réalise des livres sérigraphiés et des affiches disponibles via son site Web et dans certaines galleries. Les travaux de Smith ont fait l'objet d'expositions collectives au Royaume-Uni, en France, aux États-Unis, en Italie, au Japon et en Australie. Bien que la plupart de ses travaux soient réalisés sur ordinateur, ils gardent cette touche particulière du « fait main ».

[ES] Andy Smith es un ilustrador y rotulista que vive y trabaja en Hastings (Inglaterra). Desde que se licenció por el Royal College of Art de Londres ha trabajado para un amplio abanico de clientes británicos e internacionales, incluidos Nike, Orange, McDonalds, *The Guardian*, *Time Out*, Random House, Penguin Books y Nickelodeon. Su trabajo para publicidad, impresión, editoriales y animación ha recibido los premios D&AD, AOI y Creative Circle. Junto con sus proyectos comerciales, Smtih diseña libros y carteles serigrafiados, a la venta a través de su propia página web y en galerías seleccionadas. Las obras de Smith se han incluido en exposiciones en el Reino Unido, Francia, Estados Unidos, Japón y Australia. Aunque crea gran parte de su arte con ayuda del ordenador, mantiene una esencia característicamente artesanal.

◀◀
Big Type – page from silk-screen printed promotional book *Hand Drawn Type and Fancy Fonting*. Self published.

◀
The Big Bang – cover of a promotional brochure for the advertising agency Tequila Manchester.

▲
Blue Moose – limited edition silk-screen print.

Cover for Chris Lynch's book *Me, Dead Dad and Alcatraz*. Client: Bloomsbury.

Relax and Move to the Country – limited edition silk-screen print.

Relax & MOVE to the COUNTRY

THE
BRAIN-DEAD
MEGAPHONE

George Saunders

'Not since Twain has America produced a satirist this funny' Zadie Smith

Cover for George Saunders' collection
of short stories *The Brain Dead Mega-*
phone. Client: Bloomsbury.

The Rainy Season – a self-published
silk-screen printed book.

▲ Cover for Simon Majumdar's travelogue *Eat My Globe*. Client: John Murray Publishers.

► *Inergetical* – limited edition silk-screen print made for *Art of Lost Words*, an exhibition about forgotten English words.

Later I understood what seized my IMAGINATION that day

HOW STRANGE IT WAS TO SEE MEN DO SOMETHING BEAUTIFUL

◄
Promotional poster for Tim Winton's book *Breath*. Clients: Picador and Foyles Bookstore.

▲
Cover for Chris Addison's collection of poems *Cautionary Tales for Grown-ups*. Client: Hodder.

Spike Press

www.spikepress.com
spikepress@spikepress.com

[EN] Spike Press, a.k.a. John Solimine, is an illustrator and graphic designer based in Chicago, USA. In 2002 he started designing and screen printing posters for concerts as well as other cultural events. Since then he has been steadily expanding his skills, from using existing images and fonts to doing all the illustration and lettering himself. While printing posters in his basement Solimine worked as a designer of websites in an advertising agency. He finally found the opportunity to leave his job at Leo Burnett in 2006 and switched to poster design and illustration full time. Spike Press' clients include American Express, *The Chicago Tribune*, Nike and others. His work has been featured in *Communication Arts*, *Print Magazine*, *Naïve* (published by Gestalten) and other publications.

[DE] Spike Press alias John Solimine aus Chicago, USA, ist Illustrator und Grafikdesigner. 2002 begann er Poster für Konzerte und andere Kulturevents zu entwerfen und als Siebdrucke zu produzieren. Seither hat er seine Fertigkeiten kontinuierlich ausgebaut und arbeitet inzwischen nicht nur mit vorhandenem Bild- und Schriftenmaterial, sondern entwirft auch Illustrationen und Schriften selbst. Solimine arbeitete zuerst als Webdesigner in einer Werbeagentur, während er in seinem Basement Poster produzierte. Schließlich konnte er 2006 den Werbejob bei Leo Burnett aufgeben und sich ganz dem Plakatdesign und der Illustration widmen. Zu den Spike Press-Auftraggebern zählen u. a. American Express, *The Chicago Tribune* und Nike. Solimines Arbeiten wurden schon in *Communication Arts*, *Print Magazine*, *Naïve* (erschienen im Gestalten Verlag) und anderen Publikationen präsentiert.

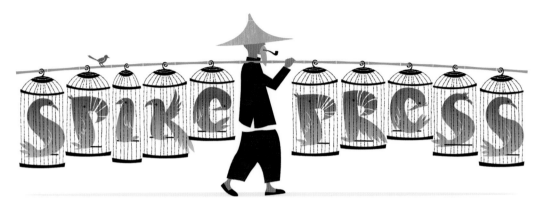

[FR] Basé à Chicago (USA), Spike Press, alias John Solimine, travaille comme illustrateur et designer graphique. En 2002, il se lance dans le design et l'impression sérigraphique d'affiches de concerts et autres évènements culturels. Depuis, il n'a fait qu'étendre ses compétences, passant de l'emprunt d'images et de fontes existantes à la réalisation d'illustrations et de typos de A à Z. Après avoir cumulé un poste de concepteur de sites Web et ses activités d'affichiste dans son sous-sol, Solimine trouve enfin l'occasion de quitter son poste chez Leo Burnett en 2006 pour se consacrer à temps plein à la conception d'affiches et à l'illustration. Spike Press compte parmi ses clients American Express, *The Chicago Tribune* et Nike. Ses travaux ont été publiés dans des magazines tels que *Communication Arts*, *Print Magazine* et *Naïve* (édité chez Gestalten).

[ES] Spike Press, alias John Solimine, es un ilustrador y diseñador gráfico afincado en Chicago (Estados Unidos). En 2002 empezó a diseñar y serigrafiar pósters para conciertos y otros eventos culturales. Desde entonces ha ido ampliando su campo de acción y ha pasado de usar fuentes e imágenes de otros a hacer toda la ilustración y el rotulado él mismo. Solimine compaginaba la impresión de carteles en su sótano con el diseño de sitios web en una agencia de publicidad. Finalmente, en 2006 encontró la oportunidad de dejar su empleo en Leo Burnett para consagrarse al diseño de carteles y la ilustración a tiempo completo. Entre los clientes de Spike Press figuran American Express, *The Chicago Tribune* y Nike, entre otros. Su obra se ha publicado en *Communication Arts*, *Print Magazine*, *Naïve* (editada por Gestalten) y otras revistas.

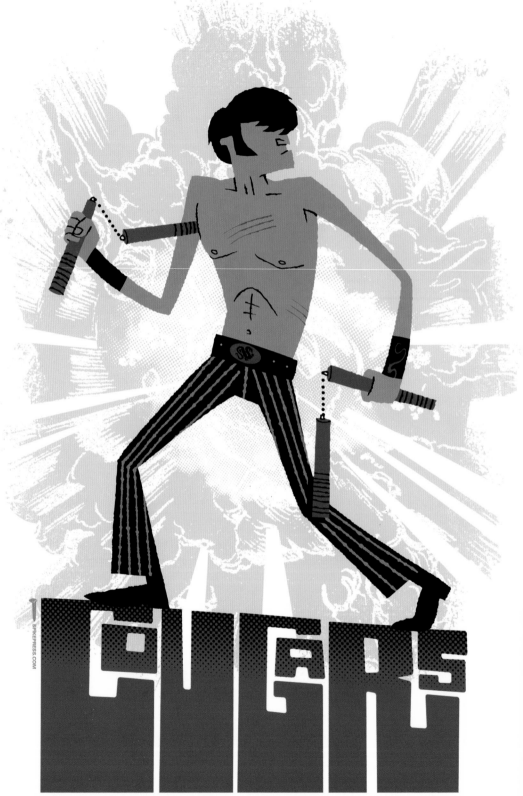

MARY TYLER MORPHINE • THE ARRIVALS • JOHNNY VOMIT • SATURDAY DECEMBER 16 • DOUBLE DOOR • 9:00 PM • $10

◄◄
Vinyl Spike Press banner. Self promotion.

◄
Silk-screen poster for a concert of the Cougars.

▲
Silk-screen poster for a concert of the Cougars and Horace Pinker.

Mural for the Domani
Studios.

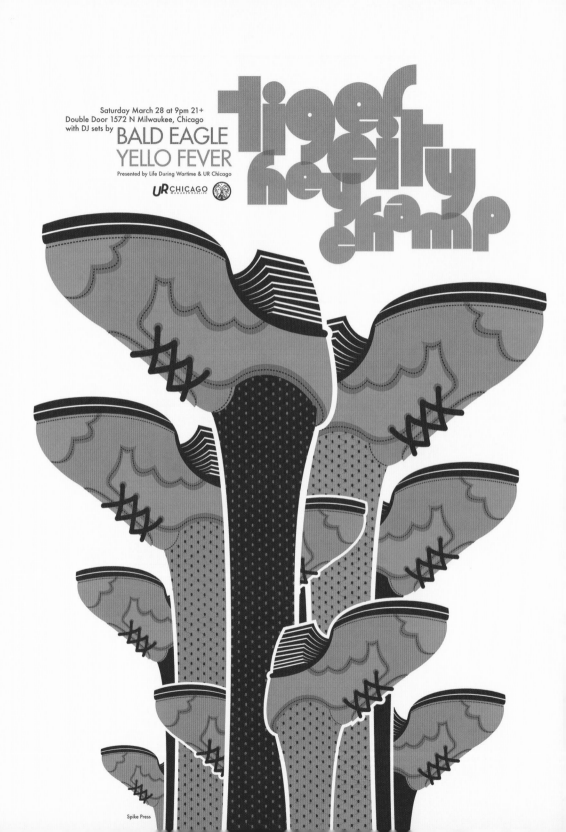

Saturday March 28 at 9pm 21+
Double Door 1572 N Milwaukee, Chicago
with DJ sets by
BALD EAGLE
YELLO FEVER
Presented by Life During Wartime & UR Chicago

URCHICAGO

tiger
hey city
champ

Spike Press

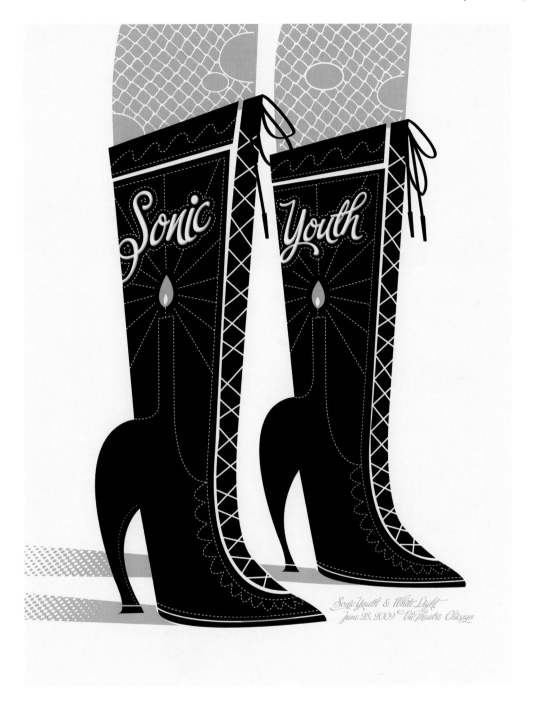

◄
Silk-screen poster for a concert of Tiger City and Hey Champ. Client: Metro Chicago.

▲
Silk-screen poster for a concert of Sonic Youth. Client: OMG Posters.

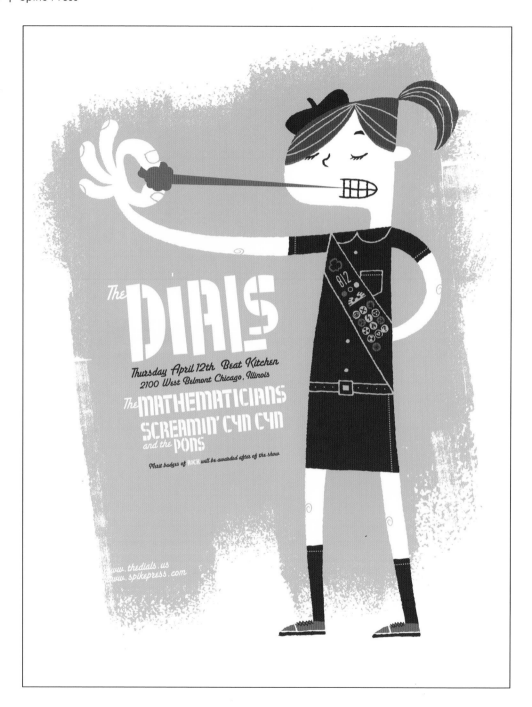

Silk-screen poster for a concert of The Dials.

Silk-screen poster for a concert of Ben Gibbard. Client: Jam Productions.

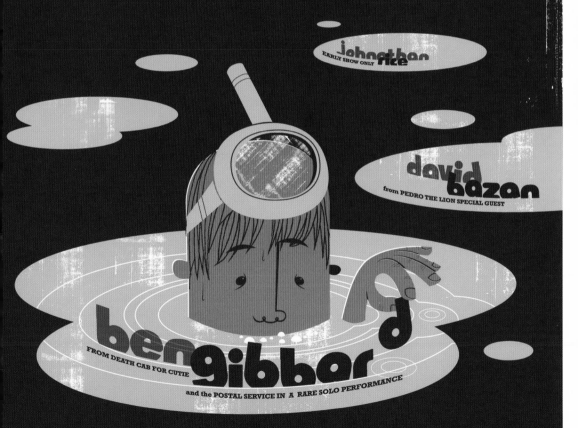

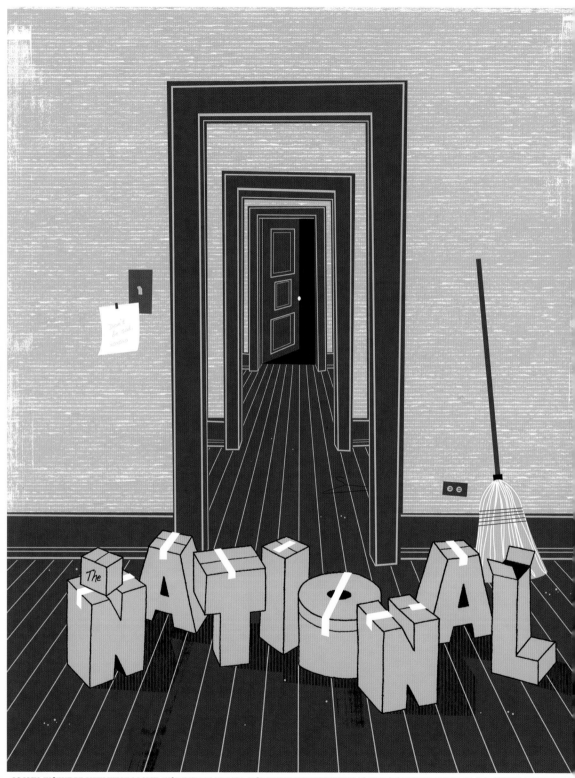

28 MAY: W/ THE BROKEN WEST **29 MAY:** W/ DOVEMAN **30 MAY:** W/ MY BRIGHTEST DIAMOND **31 MAY:** W/ ELYSIAN FIELDS **01 JUN:** W/ THE PHILISTINES

BOWERY BALLROOM NEW YORK, NEW YORK

DESIGNED BY SPIKE: spikepress.com / PRINTED BY SCREWBALL: screwbal

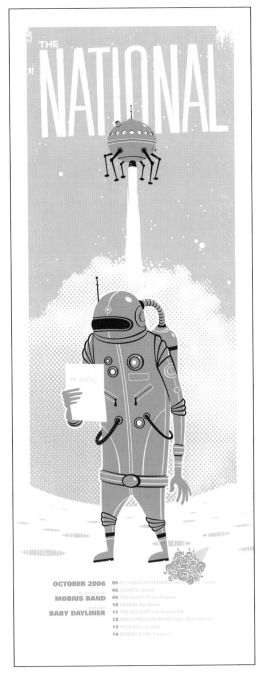

◄ Silk-screen poster announcing The National's May 2007 concerts at the Bowery Ballroom in NYC.

▲ Silk-screen poster for The National's August 2008 concert in Central Park.

▲ Silk-screen poster anouncing The National's October 2006 concerts.

Martin tom Dieck

www.mtomdieck.net
post@mtomdieck.net

[EN] Martin tom Dieck was born in Oldenburg, Germany. In 1992 he finished his illustration studies at the University of Applied Arts in Hamburg. His diploma work, focusing on sequential art, resulted in the graphic novel *Der unschuldige Passagier*, which was published in 1993. For this book he was awarded the 1994 Max-und-Moritz prize for best German-language comic publication. In 2000 he received his next Max-und-Moritz prize, but this time for best German-language comic artist. His graphic novels and picture books have been published in German, French, Finnish, Dutch and other languages. Tom Dieck teaches illustration at the Muthesius Academy of Fine Arts and Design in Kiel, Germany. He has produced illustrations for *Libération* and *Der Spiegel*, among others.

[DE] Martin tom Dieck, geboren in Oldenburg, schloss sein Illustrationsstudium an der Hamburger Fachhochschule für Gestaltung 1992 ab. Seine Diplomarbeit über sequenzielle Kunst mündete in die 1993 veröffentlichte Graphic Novel *Der unschuldige Passagier*. Für dieses Buch erhielt er den 1994er Max-und-Moritz-Preis für die beste deutschsprachige Comic-Publikation. Schon 2000 wurde er mit dem nächsten Max-und-Moritz-Preis gewürdigt, diesmal als bester deutschsprachiger Comic-Künstler. Seine Graphic Novels und Comicbücher sind u. a. auf Deutsch, Französisch, Finnisch und Niederländisch erschienen. Tom Dieck ist Professor für Illustration an der Muthesius Kunsthochschule Kiel und hat u. a. für die *Libération* und den *Spiegel* illustriert.

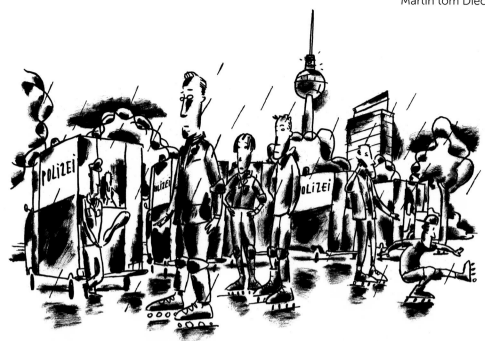

[FR] Né à Oldenburg, en Allemagne, Martin tom Dieck est diplômé de l'École supérieure des Arts Appliqués de Hambourg où il termine ses études d'illustration en 1992. Son projet de fin d'étude, consacré à l'art séquentiel, débouche en 1993 sur la publication d'un roman graphique intitulé *Der unschuldige Passagier*. Ce livre lui vaut en 1994 le « Max-und-Moritz-Preis » qui récompense le meilleur album de BD en langue allemande. Six ans plus tard, il reçoit sont deuxième « Max-und-Moritz-Preis » qui récompense cette fois-ci le meilleur dessinateur de BD en langue allemande. Ses romans graphiques et ses albums sont édités entre autre en allemand, en français, en finlandais et en néerlandais. Tom Dieck enseigne l'illustration à l'Académie des Beaux-Arts de Kiel, la Muthesius Kunsthochschule, en Allemagne. Il a réalisé des illustrations pour la presse et notamment *Libération* et *Der Spiegel*.

[ES] Martin tom Dieck nació en Oldenburg (Alemania). En 1992 concluyó sus estudios de ilustración en la Universidad de Artes Aplicadas de Hamburgo. Su tesina, que versaba sobre el arte secuencial, fue la génesis de la novela gráfica *Der unschuldige Passagier*, publicada en 1993. Tom Dieck recibió el premio Max-und-Moritz en 1994 al mejor cómic en alemán. En 2000 fue galardonado con un nuevo premio Max-und-Moritz, en esta ocasión al mejor artista de cómic en alemán. Sus novelas gráficas se han publicado en alemán, francés, finés, holandés y otros idiomas. Tom Dieck enseña ilustración en la Academia Muthesius de Bellas Artes y Diseño de Kiel (Alemania). Ha producido ilustraciones para *Libération* y *Der Spiegel*, entre otras publicaciones.

４面

ブルー・モンク

◄◄
Illustration for the French newspaper
Libération.

◄
Thelonious Monk. Personal work.

▲
Portrait illustration of Kofi Annan for
the German newspaper *Frankfurter
Allgemeine Sonntagszeitung.*

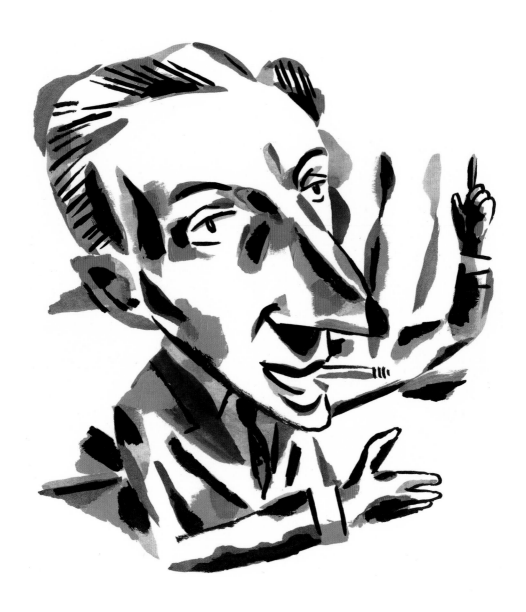

Portrait of the poet Walter Mehring for
the literature supplement of the German
weekly newspaper *Die Zeit*.

Illustration for the French newspaper
Libération.

Illustration for the French newspaper *Libération*.

Illustration for the cover of the German comic magazine *Strapazin*.

Irina Troitskaya

www.irtroit.com
irina@irtroit.com

[EN] Irina Troitskaya is an illustrator from Izhevsk, Russia. After finishing her studies in History of Art at the Udmurt State University, she was unsure if she wanted to be an artist, so she went to work for a local TV station as presenter of an arts programme. In 2003, however, she decided to return to drawing and moved to Moscow where she has since produced illustrations for a wide variety of magazines and other clients. Since 2005, Troitskaya has been teaching on the visual communications course of the British Higher School of Art and Design in Moscow. Alongside her teaching and freelance assignments, she still finds the time to paint nesting dolls, make masks and design toy figures. In these personal works and sketchbooks, her passion for drawing is most apparent.

[FR] Irina Troitskaya aus Ischewsk, Russland, ist Illustratorin. Da sie nach Abschluss ihres Kunstgeschichtestudiums an der Udmurtischen Staatlichen Universität noch zögerte, sich fürs Künstlerdasein zu entscheiden, wurde sie zunächst Moderatorin einer Kunstsendung für einen Lokal-TV-Sender. 2003 beschloss sie wieder zu zeichnen und zog nach Moskau, wo sie seither Illustrationen für unterschiedlichste Zeitschriften und andere Auftraggeber übernimmt. Seit 2005 unterrichtet Troitskaya einen Kurs für Visuelle Kommunikation an der British Higher School of Art and Design in Moskau. Neben Lehrtätigkeit und Auftragsarbeiten als Freelancerin findet sie immer noch Zeit, Matroschkas zu bemalen, Masken anzufertigen und Spielzeugfiguren zu entwerfen. In diesen persönlichen Arbeiten und ihren Skizzenheften tritt ihre Leidenschaft fürs Zeichnen besonders deutlich zu Tage.

[FR] Originaire de Izhevsk, en Russie, Irina Troitskaya travaille comme illustratrice. Ses études d'Histoire de l'Art de l'Université d'Udmurt terminées, elle hésite à embrasser la vie d'artiste et accepte un poste dans une chaîne de télévision locale comme présentatrice d'une émission artistique. En 2003, elle revient cependant à sa première passion, le dessin, et s'envole pour Moscou où elle réalise désormais des illustrations pour une grande variété de magazines et de clients. Depuis 2005, Troitskaya est professeur de communication visuelle à la British Higher School of Art and Design de Moscou. Parallèlement à ses cours et ses activités de free-lance, elle trouve toujours le temps de s'adonner à la peinture de poupées russes, la création de masques et le design de figurines. C'est dans son travail personnel et ses carnets de croquis que sa passion pour le dessin est la plus apparente.

[ES] Irina Troitskaya es una ilustradora nacida en Izhevsk (Rusia). Tras finalizar sus estudios en historia del arte en la Universidad Estatal de Udmurt tuvo dudas acerca de si quería ser artista, de manera que empezó a trabajar para una cadena televisiva local como presentadora de un programa sobre arte. En 2003, no obstante, decidió retomar el dibujo y se trasladó a Moscú, donde desde entonces ha producido ilustraciones para una amplia variedad de revistas y otros clientes. Desde 2005, Troitskaya imparte un curso sobre comunicación visual en la Escuela Superior Británica de Arte y Diseño de Moscú. Entre su labor docente y sus encargos como freelance encuentra tiempo para pintar matrioskas, esculpir máscaras y diseñar figuras de juguete. En estas obras y libros de bocetos es donde más se evidencia su pasión por el dibujo.

◄◄ *Hollow Bear* toy prototypes (sculpted by Sergey Kruk). Background: papier mâché bird mask. Personal work.

▲ Two acrylic paintings on clothing labels. Personal work.

► Illustration (detail) about mortgages for the Russian magazine *Popular Finances*.

R YOU REALLY THE ONE YOU WANTED TO B?

◄▲
Set of seven (six shown) nesting dolls based on the most popular characters from Russian fairy tales. Personal work.

◄
Set of seven (six shown) nesting dolls depicting animals that are naturally white. Personal work.

▲
Gouache painting on clothing label. Theme: 'Are you really who you wanted to be?'. Personal work.

▲
Illustration of St Basil's cathedral for a sight-seeing catalogue about Moscow.

◄
Illustration. Self pro-motion.

►▲
Papier mâché bear mask. Personal work.

►
Paper version of the papier mâché bear mask shown above. Personal work.

bear mask

by irina troitskaya
http://irtroit.com

1

2

notes:

———— → cut

·········· → bend

1

3

2

4

3

4

to: ··········

from: ·········

Jack Usine

www.usine.name
jack@usine.name

[EN] Jack Usine is one half of the design duo GUsto. Together with the other half, Fanny Garcia, he has been running his own design practice since 2005, when they both graduated from the school of fine arts in Bordeaux, France. In 2008, Pyramyd publishers dedicated one book in their 'design& designer' series to their work. Alongside his graphic design work, Usine is mostly known for his typeface designs, mainly released through his own type foundry SMeltery. His latest typeface, Vidange, was released through Psy/Ops. Usine's passion for letters knows no limits. As well as creating typefaces he paints murals and maintains the website *Jules Vernacular* (www.vernacular.fr), where he publishes an ever-growing collection of photos of old French commercial lettering on shops and other buildings.

[DE] Jack Usine ist die eine Hälfte des Design-Duos GUsto. Zusammen mit der anderen Hälfte namens Fanny García arbeitet er seit dem Studienabschluss, den beide 2005 an der École des Beaux-Arts im französischen Bordeaux machten, als Freelance-Designer. 2008 widmete Pyramyd Éditions der Arbeit der beiden einen Band ihrer „design&designer"-Serie. Neben seiner grafischen Arbeit ist Usine vor allem für seine Schriftdesigns bekannt, die er größtenteils in seiner eigenen Foundry SMeltery veröffentlicht. Seine neueste Schriftart Vidange ist bei Psy/Ops erschienen. Usines Leidenschaft für Lettern kennt keine Grenzen. Er entwirft nicht nur Schriften, sondern malt auch Wandbilder und unterhält die Website *Jules Vernacular* (www.vernacular. fr), auf der er eine stetig wachsende Sammlung von Fotos alter französischer Werbeschriftzüge von Läden und anderen Gebäuden präsentiert.

[FR] Jack Usine et Fanny Garcia, tous deux diplômés de l'École des Beaux-Arts de Bordeaux, France, opèrent en tant que designers indépendants sous le nom de GUsto depuis 2005. En 2008, la maison d'édition Pyramyd leur consacre un ouvrage dans sa collection « design&designer ». Outre ses travaux de graphisme, Usine doit principalement son succès à ses fontes customisées, distribuées par la fonderie SMeltery, dont il est le fondateur. Sa dernière police, Vidange, est quant à elle publiée chez Psy/Ops. La passion d'Usine pour les lettres ne connaît aucune limite. Parallèlement à la création de fontes, il réalise des peintures murales et s'occupe de la maintenance du site Web *Jules Vernacular* (www.vernacular.fr), où il présente une collection toujours grandissante de photos de « Lettres œuvrières et incongruités typographiques » croquées sur de vielles publicités, panneaux et enseignes de magasins français.

[ES] Jack Usine es una de las mitades del dúo de diseño GUsto. Junto con la otra mitad, Fanny Garcia, dirige su propio estudio de diseño desde 2005, año en que ambos se licenciaron por la Escuela de Bellas Artes de Burdeos (Francia). En 2008, la editorial Pyramyd dedicó a la obra de GUsto un volumen de su serie «design&designer». Aparte de por su trabajo con el diseño gráfico, Usine es célebre por sus diseños de tipografías, publicadas en su mayoría por su propia fundición, SMeltery. Su última fuente, Vidange, salió al mercado con Psy/Ops. La pasión de Usine por la caligrafía no conoce límites. Además de crear tipografías, pinta murales y mantiene el sitio web *Jules Vernacular* (www.vernacular.fr), donde publica una colección inacabable de fotografías de antiguos letreros comerciales franceses encontrados en establecimientos y otros edificios.

L'Hurlu
berlu
AHURI
à LA LUNE
HURLE

◄◄
Logo for Usine's own
SMeltery type foundry,
through which he of-
fers both commercial
and free fonts.
www.smeltery.net

◄
Mural for the group
exhibition of the
Sainte-Machine
collective, entitled
Quiproquo.

►
Flyer for the group
exhibition of the
Sainte-Machine
collective, entitled
Quiproquo. Designed
with Fanny Garcia.

▲
Poster for the exhibition *Art & Paysage*.
Designed with Fanny Garcia. Client:
Artigues-Près-Bordeaux.

▶
Promotional poster for the ornamental
font family *Soupirs*. Designed with
Fanny Garcia.

une expo photo de
Marion Rebier
///////// 1e PARTIE /////////
LA CENTRALE
I5, rue Bouquière / Bordeaux
~~~~~~~~~~
## DU 15 AVRIL
## AU 15 MAI 2007
~~~~~~~~
vernissage
samedi **14 AVRIL**
→ à partir de **19H**
+ + + + + + + + + + +
+CONCERT
de Milla Rayen
chansons d'Amérique Latine
+ + + + + + + + + + +

Contacts : lacentrale.bordeaux@free.fr / 05.56.51.79.16 &c marionrebier@hotmail.com

graphisme → Garcia Usine studio - www.gusine.fr /// imprim Rodriguez

◄
Poster for Marion Rebier's photo exhibition *Voyage Mexicain*. Designed with Fanny Garcia.

▲
Flyer/programme for CAPC Museum of Contemporary Art. Designed with Fanny Garcia.

►►
Usines (Factories) – murals. Top of page 304: mural in cooperation with Fanny Garcia. Personal work.

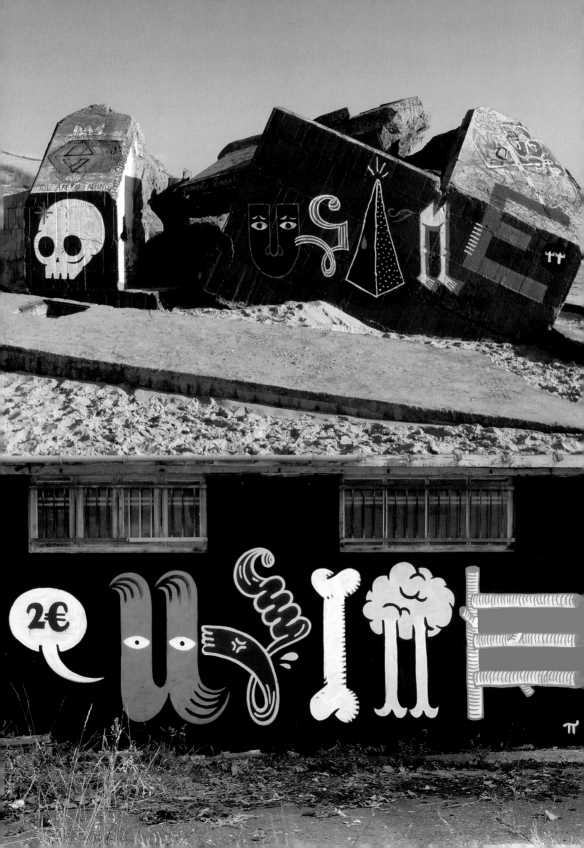

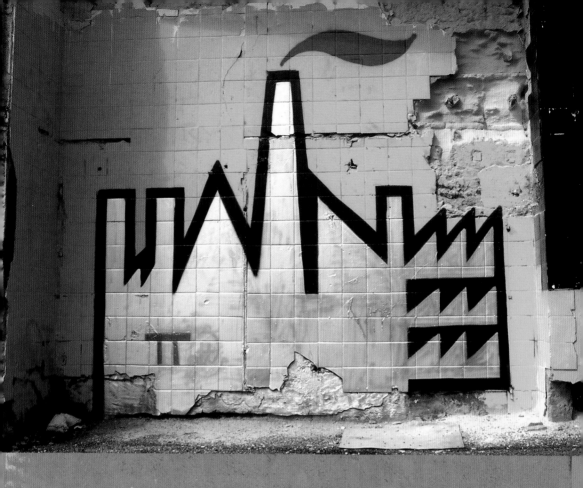

▲ *Together Everything Becomes Possible* –
limited edition silk-screen print, part of
the *Mythographies* series.

▶ T-shirt for skate-site.com. Designed
with Fanny Garcia.

SkateSite

skate-site.com

Henning Wagenbreth

www.wagenbreth.com
mail@wagenbreth.com

[EN] Henning Wagenbreth studied at the Berlin Weissensee School of Art. He is active as a freelance illustrator and graphic designer, creating paintings, posters, editorial illustrations, fonts, book and record sleeves as well as comics. Wagenbreth received international attention for his book *Cry For Help: 36 Scam E-mails from Africa*, published in 2006 by Gingko Press. He likes to stretch his style to its limits by using different techniques, such as linocuts, pixel-, vector- and pen-drawings. But whatever technique he chooses, it is always unmistakably a Wagenbreth. His automated illustration system (named 'Tobot') is a recurring theme in his free works. In 1994 he started teaching visual communication at the Berlin University of the Arts, where he is still a professor today.

[DE] Henning Wagenbreth studierte an der Kunsthochschule Berlin-Weißensee. Er arbeitet als Freelance-Illustrator und -Grafikdesigner, malt und gestaltet Poster, Illustrationen für Periodika, Schriften, Buch- und CD-Covers sowie Comics. Wagenbreth machte international durch sein 2006 bei Gingko Press erschienenes Buch *Cry For Help: 36 Scam E-mails from Africa* von sich reden. Mit unterschiedlichsten Techniken wie Linolschnitt, Pixel- und Vektorgrafiken und Federzeichnungen lotet er gern die Grenzen des eigenen Stils aus. Doch welches Medium auch immer er wählt – es wird immer ein „echter Wagenbreth". Sein automatisches Illustrationssystem Tobot ist ein wiederkehrendes Motiv seiner persönlichen Arbeiten. 1994 begann er Visuelle Kommunikation an der Berliner Universität der Künste zu lehren und hat dort bis heute eine Professur inne.

[FR] Artiste prolifique - illustrateur free-lance, designer graphique, peintre, affichiste, illustrateur éditorial, typographe, réalisateur de couvertures de livres et de pochettes de disques ainsi que de bandes dessinées - Henning Wagenbreth a fait ses études à l'École supérieure des Beaux-Arts de Berlin-Weissensee. Wagenbreth a retenu l'attention de la communauté internationale avec la publication de son livre *Cry For Help: 36 Scam E-mails from Africa*, chez Gingko Press en 2006. Il aime pousser son style jusqu'aux limites de l'expérimentation en faisant appel à diverses techniques comme la gravure sur linoléum, le dessin au pixel, le dessin vectoriel et le dessin à la plume. Quelle que soit la technique employée, on reconnaît un Wagenbreth. Son système d'illustration automatisée (appelé «Tobot») se retrouve de façon récurrente dans son travail personnel. Depuis 1994, il travaille comme professeur de communication visuelle à l'Université des Arts de Berlin.

[ES] Henning Wagenbreth estudió en la Escuela de Arte Weissensee de Berlín. Trabaja como diseñador gráfico e ilustrador freelance creando pinturas, carteles, ilustraciones editoriales, fuentes, portadas para libros, carátulas de discos y cómics. Wagenbreth saltó a la palestra internacional con su libro *Cry For Help: 36 Scam E-mails from Africa*, publicado en 2006 por Gingko Press. Le gusta llevar su estilo hasta el límite aplicando distintas técnicas, como linografías, dibujos con píxeles, vectores y lápiz. Ahora bien, al margen de la técnica que elija, sus obras son inconfundibles. Su sistema de ilustración automatizada (llamado Tobot) es un tema recurrente en sus trabajos personales. En 1994 comenzó a impartir comunicación visual en la Universidad de Artes de Berlín, donde sigue ejerciendo como profesor en la actualidad.

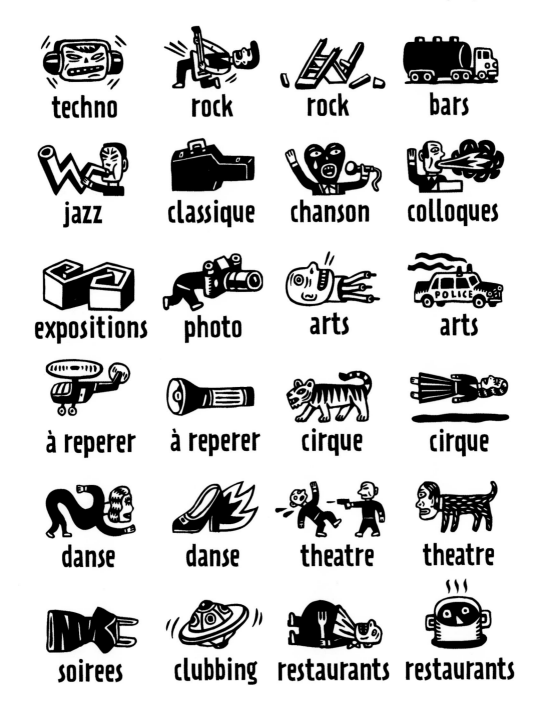

techno

rock

rock

bars

jazz

classique

chanson

colloques

expositions

photo

arts

arts

à reperer

à reperer

cirque

cirque

danse

danse

theatre

theatre

soirees

clubbing

restaurants

restaurants

◄◄
Illustration made with the automated illustration system Tobot. Personal work.

◄
Poster for Jazzfest Berlin 2003.

▲
Icons for the daily cultural calendar in the French newspaper *Libération*.

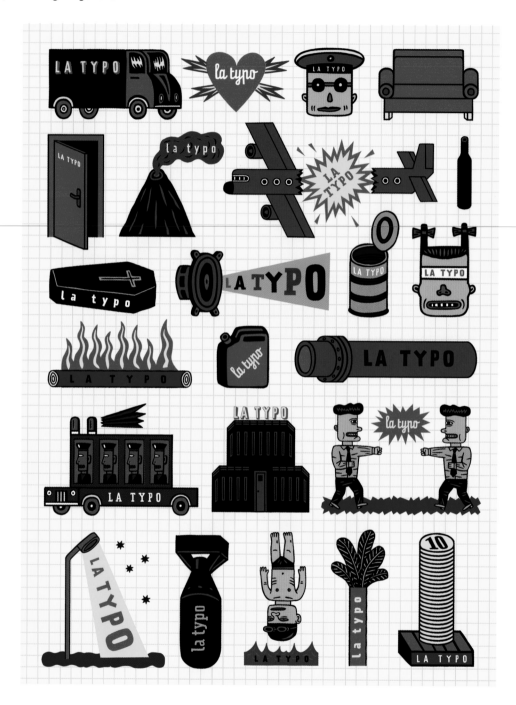

▲
Illustration for the French magazine *SVM Mac*.

▶
Poster for the *Tobot − automated illustration systems* exhibition at the Fumetto Comic Festival in Lucerne, Switzerland.

▶▶
A sheet of stamps for the *Tobot − automated illustration systems* exihibition at the Fumetto Comic Festival in Lucerne.

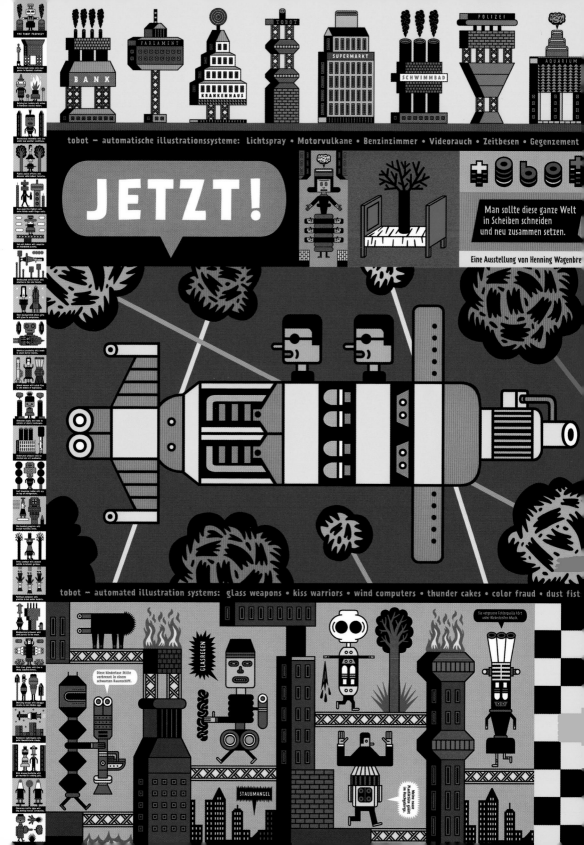

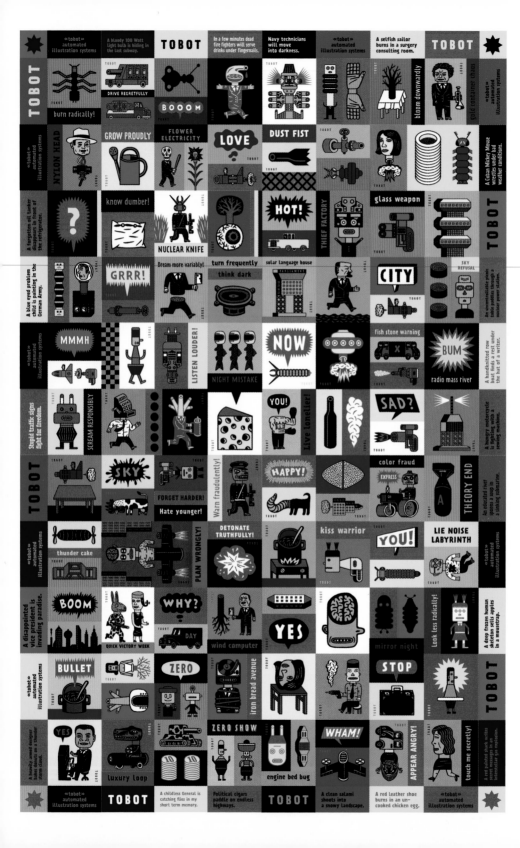

Guard

Johannesburg Street Map

Guard

Yesterday St — Tomorrow Hwy

Morning Highway
Gauteng Legal Taxis

Bullet Street
Ice Cream

Orphan Hwy

Equality St

Unemployment St
Gun Exchange
New and Used

Robbery Route
SAPS

Jewel City

Antenna Park

Scar Boulevard

Barbed Wire Ave

Emty Building St
HOTEL

Rape Town

Alarm St
chubb
armed response
chubb
armed response

Have Ave

Hijack Rd
cars wanted!
dead or alive!

HIV Positive Hwy

Democracy St
PUBLIC PHONE
PUBLIC PHONE

Have not Blvd
Dr. Ingozi solves all your problems!
Kills unwanted evil spirits, brings
back lost lovers and stolen goods.
Get rich! Correct numbers for lotto!

Arrive Alive Hwy

@ Henning Wagenbreth

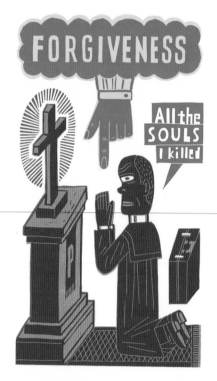

◄◄
Poster for the project
Sammeltaxi organised
by the Goethe Institut
in Johannesburg.

◄
Four illustrations from
the book *Cry For Help:
36 Scam E-mails from
Africa.* Published by
Gingko Press.

►
Illustration from the
book *1989.* Published
by Orecchio Acerbo.

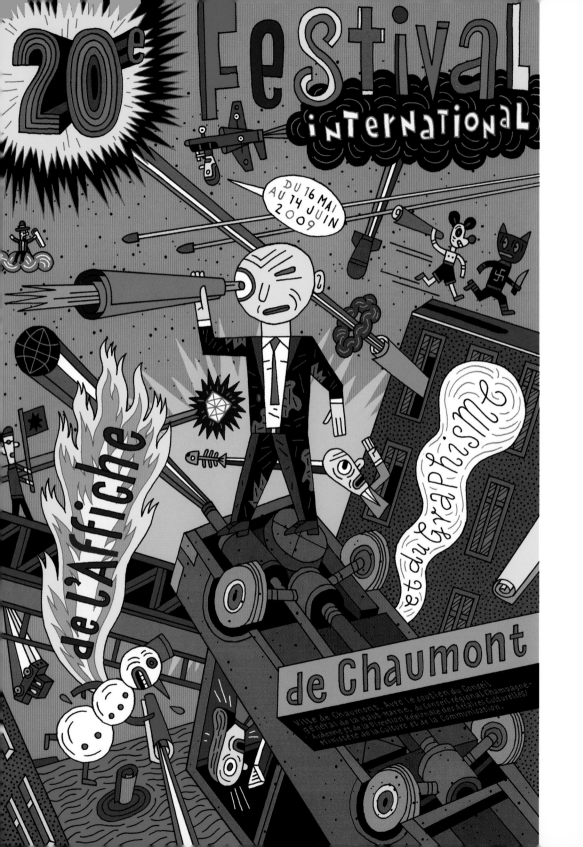

◄
Poster for the 20th edition of the Inter-
national Poster and Graphics Festival of
Chaumont.

▲
Sleeve for the LP *Taj Mahal – An Evening
of Acoustic Music*. Client: Tradition &
Moderne GmbH.

►►
Children are the Rhythm of the World –
silk-screen poster.

children are the rhythm of the world